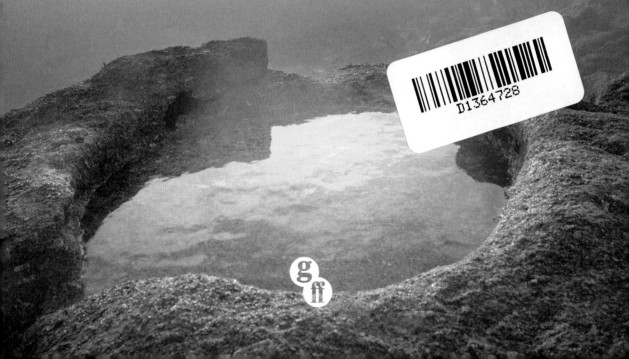

UNCOMMON GROUND

A word-lover's guide to the British landscape

Dominick Tyler

g|ff

A NOTE ON THE TEXT

The chapters in this book follow my journey across Britain, beginning in October 2013, when I took the first photographs in Devon, and ending in October 2014 in East Anglia.

This book is intended to reward dipping-in as much as reading-through. Entries are arranged according to my own sense of narrative and aesthetic flow rather than by location, type or alphabetical order. I've included standard dictionary pronunciation guides for the main terms and a non-exhaustive list of related terms. There is an index at the back of the book to help you find particular entries.

In case you want to visit the places I've photographed, I've provided OS references. Ephemeral features, such as spume, verglas or will-o'-the-wisp, which might never appear in the same place again, do not have a map reference since it wouldn't be much use.

The photographs in this book were shot on a Hasselblad 503cw camera and Kodak Ektar film. The book is set in 9.5 / 14pt Amasis Light.

For
Martha and Wilf

First published 2015
by Guardian Books, Kings Place, 90 York Way, London, N1 9GU
and Faber and Faber Ltd, Bloomsbury House,
74–77 Great Russell Street, London, WC1B 3DA

Extract from *Cider with Rosie* by Laurie Lee
Published by Vintage
Reprinted by permission of The Random House Group Limited.

A CIP record for this book is available from the British Library

ISBN 978-1783-35048-3

Text design by carrdesignstudio.com

Printed and bound by C&C Offset Printing Co. Ltd, China

Contents

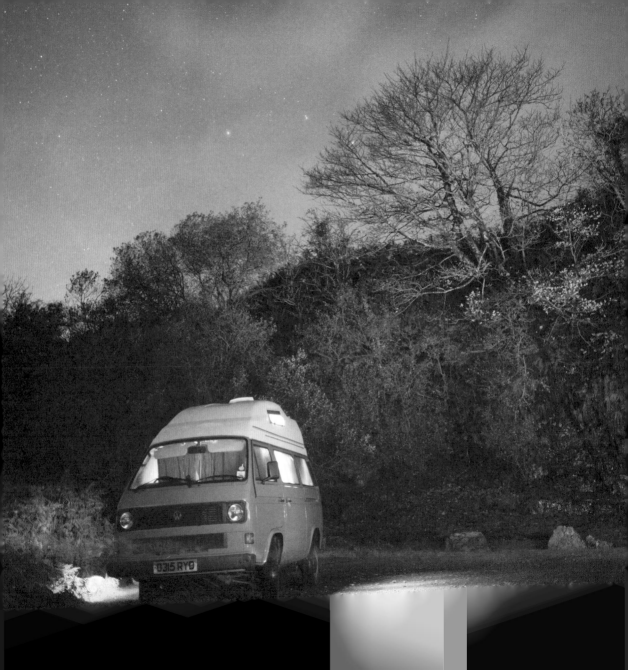

INTRODUCTION

In 2008 I collaborated with the writer Kate Rew on her book *Wild Swim*. It was a rare and wonderful project, an opportunity to travel throughout the UK finding and photographing the best places to swim outdoors. The work took us to the Outer Hebrides, the Isles of Scilly and hundreds of watery places between, and in the course of that year, as I walked and swam around Britain, I felt a restored sense of familiarity with the natural landscape. Until I began to feel its ebbing return, I hadn't realised that this sense had ever left me. It must have drifted away when I wasn't paying attention, when, after spending the first eighteen years of my life in rural Cornwall surrounded by the moors, the woods and the sea, I moved to London, first to study and then to work. Throughout this time, despite my urban surroundings, I still identified myself as a rural person, I felt (or felt I felt) that my natural habitat was the countryside, even as I acclimatised to the city.

My childhood home was surrounded by green spaces, and at the age of twelve I was allowed to roam freely over a territory of fields and woods loosely defined by my parents as 'not too far'.

I knew this territory well, or at least I knew it for my purposes: the trees for climbing, the places in the river for fording or swimming, the illicit routes through gardens. Over the years I had accumulated a rough and ready knowledge of the landscape. I was free from unnecessary facts: I did not need to know whether the climbing trees were ash or sycamore, that the swimming pools were formed in the meanders of the river by fluid dynamics or that trespassing was a civil offence.

My knowledge was pertinent but also superficial. During my year of wild swimming I realised my 'knowledge' was no longer as useful or as satisfying as it had been when I was a child. In particular I found, to my shame, that my vocabulary for landscape was woefully inadequate. Back then I hadn't needed, or wanted, to communicate about my wanderings. I relied heavily on the single word 'out' when faced with questions about where I'd been or where I was going. Full disclosure would have been an unacceptable limitation on my liberty and, worse, might have led to restrictions. Now that I wanted to describe a journey across the Welsh hills accurately and effectively, it seemed I had only

1

the barest, blandest words at my command. There was a hill, then a dip, then some lumpy bits and then it got stony. It was acutely frustrating not to have the right words available, like trying to fix something without the right tools. I reasoned that there must be words for these details of the landscape precisely because I needed them in order to do what people must have needed to do for millennia: give directions, tell a story or find a place.

And so I began collecting words for landscape features, words like jackstraw, zawn, clitter and logan, cowbelly, hum and corrie, spinney, karst and tor. As they filled my notepads I saw that these words were as varied, rich and poetic as the landscapes they described. Many of them go above and beyond the basic job description of a noun: 'ooze' does not just refer to an estuarial mudflat, it evokes it, as does 'gloup' for a tidal blowhole and 'swash' for the action of a wave on a beach. Of course for common landscape features there are several words in different languages and dialects: a 'corrie' in Scotland is a 'cwm' in Wales and a 'coombe' in England, all of them referring to an amphitheatre-like valley formed by glacial erosion. You could fill a book with words for a hill alone. Other features, unique to one area, are only named in that region's dialect, although sometimes the word is adopted elsewhere for related features. Regional language reflects regional geography and

human concerns: in Scotland there are Gaelic words to describe mountain peaks by their sharpness, whereas in Norfolk the dialect has more to say about degrees of waterlogging.

An accumulation of these words amounts to a glossary of the British landscape, which, I realised, is exactly what I'd needed in the first place. Dictionaries of geography were useful, but missed out great chunks of colloquialism, and works on dialect rarely had the detail I was after. The one book I did find that breached conventional typologies was Barry Lopez's *Home Ground*, which became a key inspiration for this project.

Rather than attempt an encyclopedic work like Lopez, I wanted to create a primer that would encourage and illuminate further reading, a touch-paper that would ignite interest. A definitive glossary of landscape would contain many dull pictures of fascinating things and many fascinating pictures of dull things. This work is not meant to be definitive, nor encyclopedic, nor dull, so I decided to select features that, I hope, make for interesting words and pictures. Aside from this aspiration, the selection is deliberately arbitrary and by no means should be thought of as a landscape 'best of'. Failure to visit any or all of the places featured before you die is not something I want you to worry about. The material for this book was gathered in a series of field trips that together provided

a representative spread of landscapes from the Cairngorm mountains to the Cornish coast. I learnt geology, geography, history, etymology, linguistics and lore as I travelled, and *Uncommon Ground* has become both my exercise book for these lessons and my rambling songline across Britain.

Photography has been my way of investigating the world for the last twenty years; it would have been practically impossible for me to make sense of this journey without a camera. The process of photography is a lot to do with creative exclusion. Choosing what to leave out of a picture is often more important than choosing what to include. This book presents the truth, but not the whole truth: in selecting one, single example of a landform to photograph I am, apparently, offering an archetype. But they are often atypical or extraordinary examples simply because those are the most interesting. Between the text and the photograph I hope to define both the necessary characteristics and also something about the essence of each feature.

As well as simply informing, I hope this work will raise questions about our relationship with the environment, and the changes that this relationship has undergone. For as long as humans have communicated, we have done so about our surroundings. But these surroundings have changed.

My move from country to town followed a general trend that started during the industrial revolution. Our increasingly urbanised lives and the resulting loss of rural knowledge means that much of the language developed for this communication have become vestigial, and many of the words I've collected have fallen into obscurity (most of them are lit up by a standard spellcheck; many return only typos in a web search). In general, we no longer need to be able to describe the landscape with precision and detail. Where a specific need remains, for example among mountaineers, coastal fishermen or wetland farmers, pockets of language persist like oases. Our growing estrangement from the landscape mirrors a growing unease with the natural world. We want to keep the outside out, the countryside has become the unfamiliar 'other', a threat to be overcome and dominated, not understood and enjoyed. Might this partly be because we feel uncomfortable with things for which we have no name? Perhaps we choose to render the landscape in such vague, generic terms in order to insulate ourselves from the loss of it?

There is a risk that this unfamiliarity with the actual countryside leads to a fetishised version that only really exists in our imagination. Even as I write the word 'countryside' I am aware that it's a shorthand term for a complicated knot of ideas. Adding to the tangle are conflicting concepts of

the countryside as a 'natural' environment. In the country, we are surrounded by nature, but for the most part it's nature bent to the will of man. This is, after all, a smallish island whose land resources have had to be exploited to supply the demands of a biggish population. Landscape and waterscape features that show human influence, historic or modern, are not excluded from this book. For me, any useful definition of the 'natural' landscape must include humans and human influence, and I have tried to resist the impulse to sanitise my images by cropping out pylons and roads. Hardly any people appear in the photographs in this book, but the presence of humanity is everywhere: in the shape of the land and in the stories we tell about landscape.

Landscape is sometimes described as a palimpsest, bearing the marks of each event that has been written onto it like the manuscripts that were scraped clean and reused by frugal monks. Just as traces of these deleted texts can be detected, we can often read historic landscapes hidden beneath the surface. What may be more difficult to perceive are the strata of knowledge that once lay over the land, fundamental in the past but now redundant. Some of this knowledge is held in folklore, like an insect in amber, admired for its beauty but deprived of life. To really come alive, these narratives need an audience capable of navigating the physical as well as the mythological landscape, recognising the features common to both. In myth, rivers contain spirits that might lure you to your death, and in the 'real' world, the running waters themselves are as dangerous as they are attractive. The risks and rewards in the landscape become animated and personified in folklore, all the better to convey their natures. I wonder if this connection is still understood as it was, or whether these forest-, stream- and mountain-dwelling characters are now irreconcilably divorced from their actual locations. If so, have we lost anything more than superstition? By repurposing allegory as children's entertainment, have we perhaps devalued a useful store of information?

Rebuilding our landscape vocabulary might enable more complicated conversations about nature to take place, and complexity offers more than just a deeper understanding. An ecosystem is most resilient when it is most complex. The more you simplify and homogenise the system, the more susceptible to attack it becomes. A wild meadow, with its variety of species and myriad connections, will never fall to a single natural factor, as might a wheat field to a plague of locust. The greatest threat to a meadow is that it might be ploughed up and turned into a wheat field. Wherever complex natural systems are replaced by monocultures there is an increased risk of

collapse, so modern agriculture mitigates this risk with fertilisers, pesticides and herbicides. There is a parallel with what might be called 'conceptual ecosystems'. We hold a concept of landscape that has become vastly simplified and homogenised. Rather than reflecting the variety and interconnectedness of nature, our concepts are reduced to block terms like 'green field', 'brown field' and 'industrial estate'. Just as simplification renders a natural ecosystem vulnerable, so these block concepts make our ideas about landscape, and its value, fragile and easily dismantled. When in 2014 the then UK environment secretary, Owen Paterson, announced that developers might be permitted to destroy ancient woodlands, provided they planted replacement trees elsewhere, he demonstrated a mindset that results from a collapsed conceptual ecosystem. To consider trees a transferable commodity like steel or oil is a woeful misunderstanding of the value of a tree, especially an ancient tree. A mature oak can support a network of something like one thousand other species: lichens, mosses, birds and mammals, and over four hundred species of invertebrate alone. Accepting the equation of new for old could only make sense to someone whose concept of the natural landscape is so simplified and disconnected as to be rendered meaningless.

We often equate complexity with difficulty (read any 'end-user license agreement' for an example) but subtlety and intricacy is important in the natural world. In this book I'm interrogating the superficial, simple labels we use to reveal more specific terms, each one with its own set of links to others. I want to replace the general, for example 'hill' with 'stob'. I want to replace discrete knowledge with a sense of the intertwined. When the threats come, as they inevitably will, our sense of the land needs to be complex enough to resist any single attempt to dismiss it.

By starting to re-enrich our nature vocabulary and our landscape stories, I hope *Uncommon Ground* will be a reminder that there was a time when our ancestors read the lines on the land as clearly as any text. We can learn to read it again, perhaps never as fluently as before, but maybe well enough to make it feel more familiar, more real and more connected. In order for us to belong to a place, and it to us, we must first name it.

Dominick Tyler
London, 2015

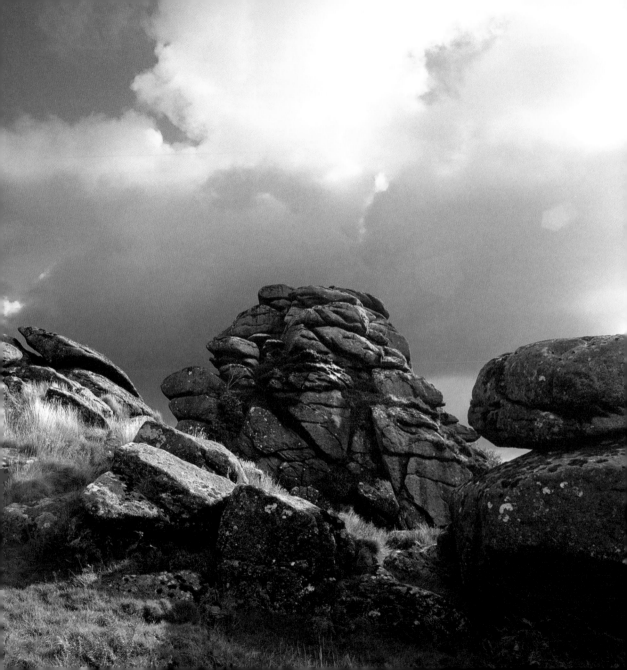

SOUTH WEST

The St Jude storm hit on 27 October 2013, the night before I was due to drive to Dartmoor. Reluctant to pit my van against 80 mph gusts, I waited most of the following day for the worst of the weather to pass. When I finally set off into the darkening evening the winds were still feisty and there was plenty of reason to ponder the significance of St Jude's patronage over lost causes. After leaving the motorway at Okehampton, each turn seemed to lead to a road narrower and more river-like than the last, until, just outside Peter Tavy, there was no practical distinction between watercourse and highway. The van ploughed upstream like an elephant raised by salmon.

Once on open moorland, above the lanes where the high hedges channelled and contained all the water, the going got easier and I was relieved to find a secluded parking area where I could stop for the night. The sweep of the headlights as I turned off the road lit the wet stone walls of a small grotto-like quarry cut into a rock face. Silencing the engine, I became aware of the sounds of sloshing water surrounding me, so intense that I wouldn't have been surprised to find I'd passed through a waterfall and was now nestled inside a hidden cave.

In the morning I woke from amphibious dreams to find my sheltering grotto made, if not drier, then less strange by weak sunlight and strong coffee. This was my first field trip and I had no set operating procedure, just a box of film, a tank of fuel, some much-annotated maps and a list of landscape features. Many of these were made from granite, and as such they owed their existence to a common factor, the Cornubian batholith.

Lying along the length of Devon and Cornwall and extending 65 miles south-west into the Atlantic, the Cornubian batholith is a mass of granite formed around 300 million years ago from magma that pushed its way up through the earth's crust.

Rather than erupting as a volcano, the magma pooled like blisters just under the pre-existing rocks, crystallising as it cooled. Since then, the softer surface layers have been eroded away and the granite has been revealed like a crocodile rising from the swamp waters – its snout is Dartmoor, its eyes Bodmin Moor, its ridged back forms the outcrops at St Austell, Carnmenellis and Land's End, and finally the Isles of Scilly are its tail. The vast bulk of the batholith remains under the surface,

beneath layers of the surrounding rock, but it makes its presence felt.

Granite is one of the toughest rocks there is, but its density is low, and as a result the batholith creates a localised gravity anomaly. Simply put, you weigh very slightly more in a place where the bedrock is denser, like the Isle of Skye, than you do in Cornwall and most of Devon. Fortunately the remedy for this is near at hand in the form of clotted cream. Mapping the extent and shape of the batholith was started by the Institute of Geological Sciences in the mid-1970s, made possible by technologies that allow fine measurement of the force of gravity.

Geology's influence over our daily lives is easy to overlook, but the rocks beneath our feet define much of what goes on above. As Richard Fortey writes in *The Hidden Landscape*, 'Lying beneath the thin skin of recorded history in our islands, geology has the same role in landscape as does the unconscious mind in psychology: ubiquitous but concealed.' Agriculture and industry naturally follow the opportunities presented by soil types and mineral resources. In addition, the subtler influences of landscape permeate other areas of local life. The batholith is the dominant geological factor shaping the landscape of the South West and its impact can be seen in the region's culture. The incursion of magma into the surrounding rock brought with it the seams of minerals that made Cornwall, at one time, the epicentre of hard-rock mining. When this industry declined, experts from the mines of Camborne, Caradon and Redruth emigrated to the mines of Africa, Australia and the Americas. They used to say that if you wanted to find a Cornishman anywhere in the world you just needed to shout 'Jack!' down the nearest hole in the ground. Without the mining industry there might well have been no Cornish pasty, the pie with a built-in disposable handle. In an environment with lots of arsenic and few opportunities for hand-washing, the pasty's crimped seam was probably a lifesaver. The best pasties I've ever had were made by Edna Dawe, who lived in our village. Rather than flaky pastry, Edna favoured a shortcrust that was so tender and savoury that the crimp would have presented an irresistible danger to tin miners.

After a morning searching for rock basins on Great Staple Tor I could not resist buying a pasty (not a patch on Edna's) from a bakery next to the Pannier Market in Tavistock. It was from a second-hand stall in this very market that I bought my first camera more than twenty years ago. The scene as I walked among the stalls, munching my second breakfast, was more or less the same. Stacks of mobile phones and DVDs had replaced the VHS tapes but that seemed to be the only difference. The scent-scape – a mixture of pet food, paperbacks

and leather – was unchanged and somehow more pervasive than the iPhones and *Breaking Bad* box sets. I only had to half-close my eyes and inhale, and time slipped backwards.

This sense of everything being different but the same accompanied me the whole time I was in the South West but it reached its peak during my stay in Cornwall. When I found myself driving the same route as my old school bus from Callington to Rilla Mill, every bend in the road was like a twist in the plot of a book I had read many times. It didn't matter that buildings along the way had been appended with a new porch or extension, they were still characters in a story I knew by heart. Slowing to a crawl to look at the house where I grew up I glimpsed a new swing-set and a new front door, small differences in an overwhelmingly familiar scene. When I was a child I belonged to that house and its surroundings, and I certainly felt that it all belonged to me. Somehow, finding it so slightly changed in my absence was as difficult to accept as finding it completely transformed. How could things be the same without me? Why didn't my leaving make everything different? I drove on, feeling unsettled by the place that was no longer my home.

I stopped down the road at Stara Bridge, once a regular destination for family walks and, later, sullen teenage wanderings. Here my feelings were less conflicted. Everything was slightly different; everything was exactly the same. My dad had once claimed that a particular boulder was the site of Tommy Brock's house, and on seeing it again I could only think of Beatrix Potter's drawing of Brock's fight with Mr Tod, or rather my version of it, set in full, frenetic colour. In the pool under the bridge, where the current always ran fast and deep and where, on hot summer days, I swam with friends until the cold stained my lips blue, the current was still running fast and deep. Innumerable quantities of water had flowed by since I had sat shivering in the sun aged eight but the river was the same river.

Twenty years of ageing showed on the faces of the friends I met up with, signs of age that you notice in your own features but that are somehow unexpected in those you see infrequently.

It's always a relief to find we can easily slip back into the skins of our younger selves. On Bodmin Moor the face of the land showed little sign of the passage of time, but then twenty years isn't long for an unmolested landscape. In another twenty thousand years climate change may have altered this place dramatically, but it may still be recognisable by its geology.

The skin, of the landscape and of people, holds a record of human histories while the rocks that lie beneath document histories stretching over timescales into which our imaginations can disappear without trace.

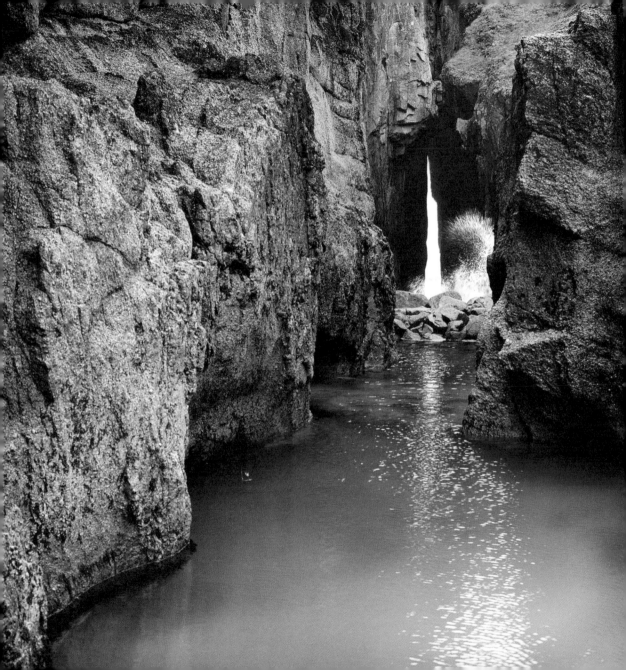

Zawn

Let's start at the end, or close to it. In flagrant inversion of alphabetisation we begin with zawns, some of the best examples of which are found near Land's End in Cornwall. Zawn is derived from 'sawan', a Cornish word for chasm (I can't help but think of a yawning chasm). If you were told that someone had fallen down a zawn, just from the sound of the word you'd be expecting some serious injury to result, maybe even passage to another world; it certainly threatens worse than a skinned knee.

These steep-sided coastal inlets are formed by wave erosion on weak spots in the cliff face. In taller cliffs, zawns can be formed when waves carve out a cave that grows until its roof collapses completely (partial collapse might result in a blowhole). Zawns may not be as ubiquitous as the Cornish pasty but the word has spread throughout the UK, used in particular by climbers identifying locations that offer an enticing combination of spectacular sea views and sheer rock. Wen Zawn on Anglesey is the location of several climbs regarded as classics, including 'A Dream of White Horses', named after the cresting waves whose inexhaustible assault formed the zawn in the first place.

The zawn pictured is at Nanjizal beach, a few miles south of Land's End, and is called Zawn Pyg ('pyg' means 'pitch' or 'tar' in Cornish, a reference to the black marks on the granite here perhaps). Its other name, 'Song of the Sea', may be more overtly lyrical but for me bears a hint of twee Victorian rebranding. This stretch of coastline, where the unhindered force of the Atlantic Ocean dashes against the seemingly immutable granite cliffs, is punctuated by zawns, a reminder that in geological terms there really is no such thing as immutable.

Tor

Granite tors are icons of endurance, riding out millions of years of erosion when softer surrounding rocks are washed, blown and cracked away to reveal the last stones standing. The word 'tor' is a survivor of linguistic weathering itself, as it's one of a small number of Celtic words in modern English.

These outcrops are common on moorland hilltops; Dartmoor and Bodmin Moor have over 200 granite tors between them. In the South West the word can be used not just for the outcrops but for the hill as well, and sometimes, as with Glastonbury Tor, it refers to a hill without a rocky summit.

Climbing a tor is one of life's great small achievements, a bite-sized mountain ascent, from the rolling foothills to the more difficult approaches as the slope steepens, then onto the bare rock for what is usually a quick scramble up to the summit.

From there you can survey the lowlands while you eat your sandwiches (it is perfectly normal at this point to feel the urge to plant a flag).

Some tors present more of a challenge: as a child and then a teenager I would circle the apparently unscalable Cheesewring tor on Bodmin Moor in mute frustration. The forces of nature have shaped this outcrop like a lopsided mushroom, slim at the base and wide at the top. As soon as you try to get up it you find yourself stuck under a massive, overhanging slab with no handholds left and not even enough room for a daring leap (I hear it has been climbed by means of a rope thrown over the top but this, of course, is cheating and doesn't count). Fittingly, 'tor' has been used as an adjective meaning 'difficult', 'irksome' or 'tedious', and, later, 'strong' or 'hard to conquer', but these uses are now obsolete.

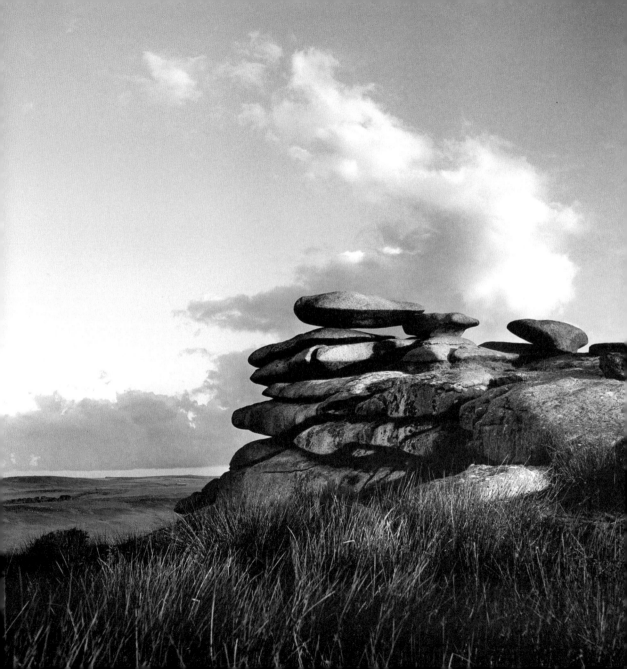

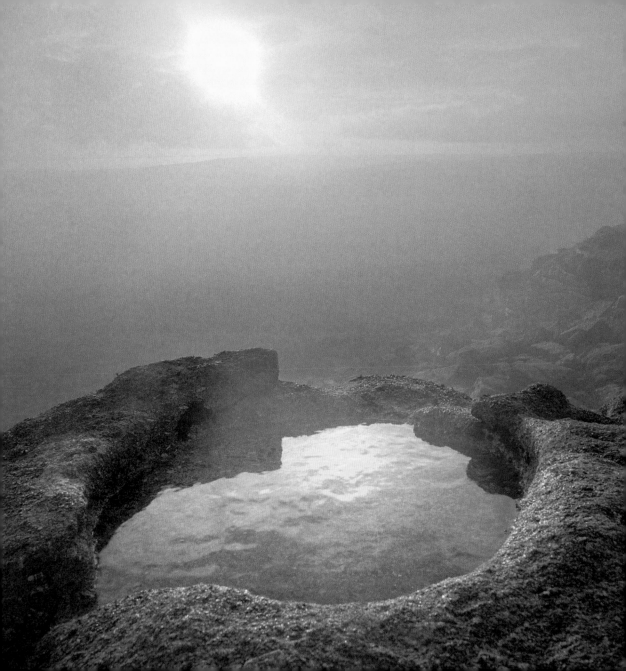

ROCK BASIN /rɒk ˈbeɪs(ə)n/

RELATED TERMS: tor, tolmen

OS: SX 562 769

Rock Basin

If, on a hot day, after a sweaty climb to the summit of a tor you found a circular basin carved into the granite and filled with cool water, you might marvel at the foresight of the stonemason who put it there. There has been plenty of speculation about the origins and purpose of these basins, but during the eighteenth century the pervading belief among antiquarians was that the druids carved them for use in their rites. 'The druids did it' became a useful thesis for the origins of many moorland phenomena that resisted other explanations, despite scarce evidence of who 'the druids' were, what they did, why they did it or whether they ever even existed. An absence of facts has prompted fevered speculation on all these points and more, but the subject of the druids' rites and rituals is one where the imagination can run particularly wild. Accordingly, the rock basins were said to have been carved for use in lustrations, either to collect pure rainwater or, better yet, the pure blood of sacrificial victims.

It might not be possible to prove categorically that no bearded, robed shaman drew a golden sickle across the slender neck of an unfortunate virgin at the top of a moonlit tor, but we do at least know that even if he used a rock basin to collect the resulting gush of blood, it wasn't made for this, or any other, purpose. In fact, the basins are formed naturally by localised erosion: ice crystals forming in puddles of water on the surface of the stones initially crack and loosen feldspar crystals in the granite; these are then blown away, creating a small dip in which water tends to collect again. The process then repeats for a few thousand years until the dip becomes a bowl.

How much more wonderful is the slow, patient work of time and the elements than some bloodthirsty cleric with a chisel and a yearning for outside plumbing.

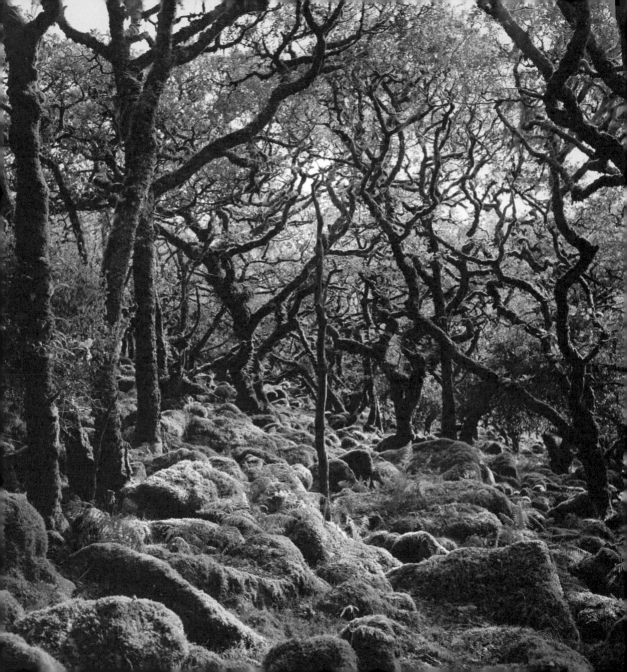

Clitter/Clatter

Devon and Cornwall are divided by many things: the River Tamar, opinion as to the correct configuration of jam and cream in a scone, and whether you say 'clitter' or 'clatter'. Clitter in Devon, clatter in Cornwall – these are the piles of irregular granite boulders that litter and clutter the hillsides around tors.

The sculpting of the tors began 280 million years ago, when the vast granite domes of Devon and Cornwall's moorland were pushed up through the Earth's crust. This extrusion of molten rock, called a 'batholith', cooled and cracked as it rose towards the surface, and these cracks were the first stage in the shaping of the stone. Millions of years of weathering and erosion added finer details, but the final flourish was accomplished during the ice ages, when water that seeped into fissures in the granite expanded as it froze and levered off rocks that then tumbled down the hills. What remained at the top were the tors, and the arisings strewn at the bottom were the clitter, or the clatter.

In massive heaps on hillsides and in valleys, these boulders create a defensive maze for small animals to inhabit. The only adder I have ever seen was basking on Cornish clatter. Being unaggressive and rare, adders are an unlikely danger, whereas sharp edges, slippery rocks and narrow crevices hidden by bracken and gorse all make clitter and clatter the perfect habitat for acquiring a broken ankle.

For many years the clitter slopes of Bodmin Moor, Dartmoor and Exmoor provided a ready source of building materials for the local inhabitants, rather like quarries that had quarried themselves. What now remains might have been too heavy or too remote to transport to a building site. The difficulty of either clearing the remaining clitter or grazing over it protects these areas from the encroachment of agriculture, allowing ancient ecosystems to endure. A fine example of this is Wistman's Wood in the West Dart valley (*pictured*).

Mire

Its tenacious grip plucked at our heels as we walked, and when we sank into it it was as if some malignant hand was tugging us down into those obscene depths, so grim and purposeful was the clutch in which it held us.

The Hound of the Baskervilles, Arthur Conan Doyle

It rains a lot on Dartmoor, and because the soil is thin and the granite beneath impervious, the water does not drain away. These are poor conditions for most vegetation but ideal for sphagnum moss, which can absorb up to twenty-five times its dry weight in water. Dead sphagnum, and other dead matter from plants growing among it, decays at a much-reduced rate thanks to chemicals in the moss, acidic conditions and lack of oxygen, and so it builds up to become a layer of peat. This layering – sphagnum moss and other wetland plants above a layer of saturated peat – is the basic structure of a peat bog, or mire.

By virtue of having a coherent but flexible mesh of vegetation on top of a mushy sludge, some mires wobble or quake when you walk over them, hence 'quagmire' derived from 'quake-mire'. These mires are sometimes called 'feather-beds' on Dartmoor, evoking their unsteadiness and the lush upholstery of moss on their surface.

No verified accounts exist of a person being sucked into one of Dartmoor's mires, but this has inhibited local storytelling as little as it did Conan Doyle. My own grandma told me about a moorland farmer who fished a hat from a mire, presuming it to have been dropped, only to find the owner sunk up to his neck beneath. As a child, the effect of hearing these stories (and watching old Tarzan films, in which panicky baddies always sank to their doom in porridgy quicksand) was a sense of slight disappointment when a false step while on tramps across the moor led only to the mild peril of an inundated boot.

TOLMEN /'tɒlmɛn/

RELATED TERM: rock basin, pothole

OS: SX 655 870

Tolmen

The two things absent from all tolmens – the stone that used to be where the big round hole is and an indication of how it was removed, make these objects a compelling mystery.

In fact, they are the result of a combination of natural forces. Obstacles in fast-flowing rivers can create vortices in the current called 'kolks', which can generate enough force to move rocks weighing many tons. On a small scale they gather up gravel and stones and, as they spin and orbit these, can bore holes called 'rock-cut basins' in bigger stones. A basin formed on an overhanging slab, as it might under a waterfall or cascade, can be deepened by freeze-thaw erosion that eventually cuts right through, leaving a neat circular hole. These holed rocks are called 'tolmen' from the Cornish for hole ('toll') and stone ('men'). We have the benefit of modern insight into fluid dynamics to explain the curious appearance of these stones. But without knowledge of these centuries-long processes –

whose timescales defy our conception – it is easy to see why our forebears reached for answers that involved supernatural forces.

Pagans, and later Christians, saw the holy in the hole. Recognising the liturgical potential of a form that suggested both a window and a portal, and thus vision and transportation, both groups made good use of it in their rituals, especially in healing. A range of complaints and diseases were treated by climbing, or being passed through, the tolmen. Those unable to fit might have consoled themselves with the promise of second sight, which could be obtained just by looking through the aperture. Hefted from their riverbeds to stand upright as they sometimes are, tolmens resemble the later works of Henry Moore. They are the ultimate expression of his abstraction of natural forms distilled down to a single negative space, and an aesthetic meeting point of the sculptor's sensibilities and the blind work of water, stone and time.

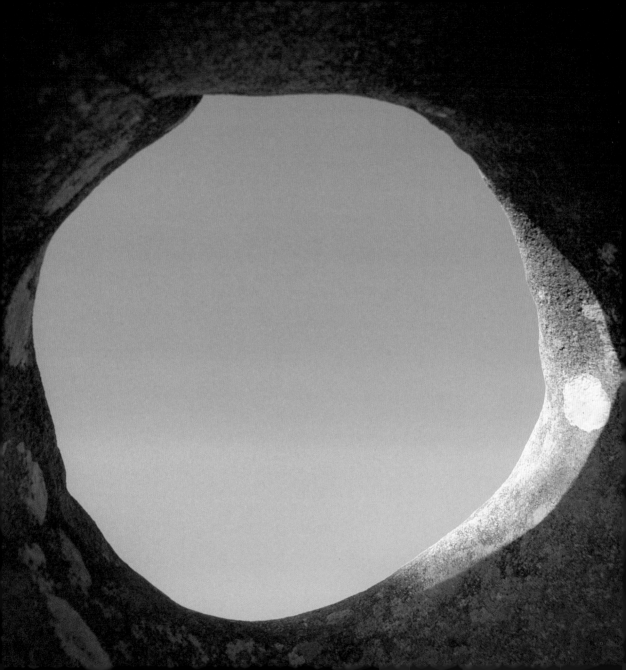

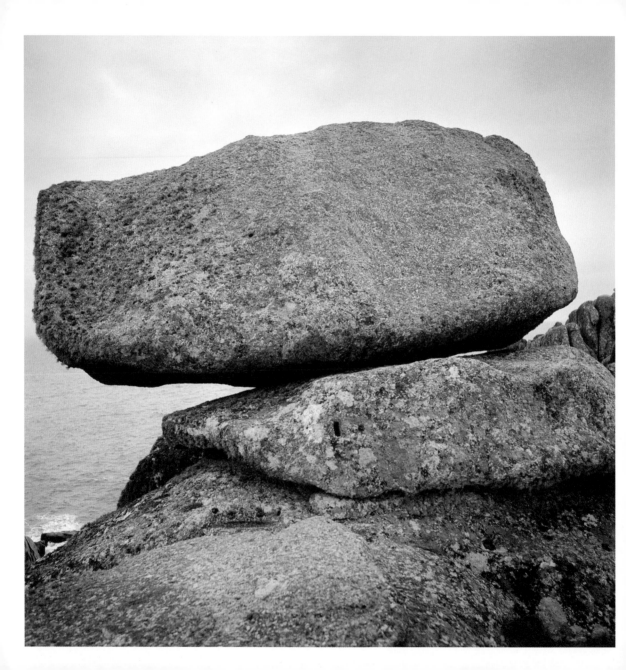

Logan

This term is used in Devon and sometimes Cornwall for a large granite stone, often part of a tor, which is supported on one or two points in such a way that it can be easily rocked to and fro while resisting any attempt to topple it completely. To 'log' in Cornish is to sway drunkenly, and 'logging' is a Devonshire word for rocking to and fro. In the eighteenth and nineteenth centuries, historians writing about the people and places of the West Country often associated logans with ancient druidic rites, but this has more to do with the preoccupations of the times than historical fact. The mechanical precariousness and massive size of some logan stones led to the popular myth that dislodging them was not just difficult but actually impossible. In 1754, the geologist and naturalist Dr William Borlase wrote of the logan stone in Treen: 'It is morally impossible that any lever, or indeed force, however applied in a mechanical way, can remove it from its present situation.' Published five years later, William Mason's poem 'Caractacus' contains a reference to the same logan, ascribing to it a power even more magical, but no less moral:

> On yonder pointed rock: firm as it seems,
> Such is the strange and virtuous property,
> It moves obsequious to the gentlest touch
> Of him whose breast is pure; but to a traitor,
> Tho' ev'n a giant's prowess nerv'd his arm,
> It stands as fixt as Snowdon.

Such theories were tested to destruction in 1824 when a squad of naval officers led by Lieutenant Hugh Goldsmith achieved the morally impossible with iron crowbars, successfully toppling the great ninety-ton stone. Some months later, following vociferous complaints to the admiralty, the Treen logan was successfully returned to its seat, but it never rocked quite so easily again, partly because it was secured with chains to prevent further mischief.

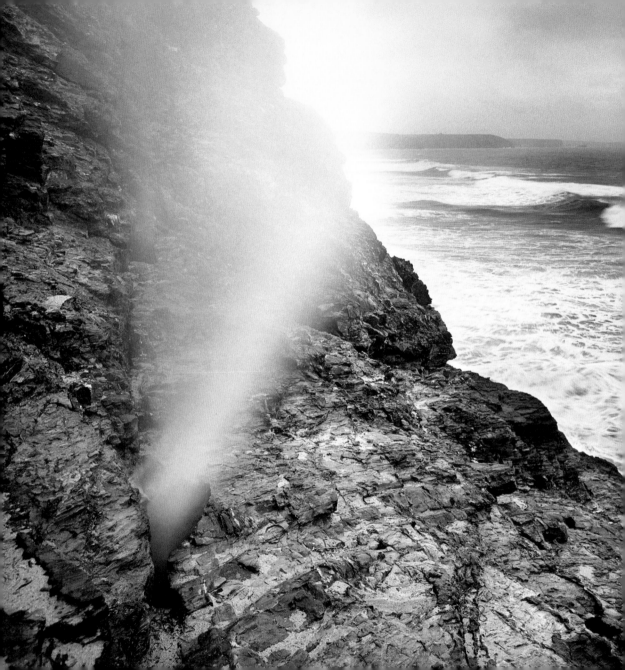

Blowhole

There is something startlingly alive about a blowhole. If you get close enough to the aperture you can hear the rock's shallow breaths, uneven and irregular, as though in fitful sleep. You might, in between spouts, look down into the hole and notice that the sides of the flue are worn smooth in soft, organic folds, carved by the air and water. The rising air that preludes a jet is salty, sticky and thicker than wind. The exhalation itself is an uncanny imitation of a sounding whale, and when it spouts the rock seems as vital as if it had reared up and bellowed.

Blowholes form under a particular set of circumstances. If the roof of a sea cave partially collapses it will sometimes open an aperture through which air and water can be pushed by the waves entering the cave below. The combination of a large cave and a small hole results in this happening at great pressure, creating a seawater aerosol. Ideal conditions for maximum expression are: a high tide, so that the waves seal the cave mouth as they rise, and high seas, so that the 'piston' waves are as big and forceful as possible. Other blowholes, formed by more extensive collapses, are too large to pressurise the airflow and may froth, foam and gurgle but never spray. Although it seems more onomatopoeically suited to this sloshing, swirling kind of blowhole, the Scottish word, 'gloup' is also applied to the spectacularly expulsive blowholes of Shetland.

Swag

This word, for a dip in the ground caused by natural or man-made subsidence, is one I'm appropriating for a landform that I think is unnamed, but shouldn't be.

On Bodmin Moor, near Minions, is a stone circle called 'The Hurlers', and this place was often the start- and endpoint of childhood walks across the moor to Gold-Diggings or up to the Cheesewring tor. Moors don't often provide much cover for games of hide-and-seek, but here, scattered about the trail, are dozens of craters into which a child can comfortably (and an adult uncomfortably) dive and hunker down out of sight. To make life more interesting, some of the craters hold water while others drain away, making a reckless choice of hiding place a risk to one's comfort for the rest of the walk. We had no particular word for these dips but 'swag' is used in America for similar, though usually larger, landforms and I'd like to adopt it (or possibly 'swaglet') in honour of the significance these dips have to my childhood memories.

Summer heat can be so entirely commuted by brutal moorland winds that the reptilian pleasure of warmth on skin is denied, but nestled in the crook of a swag that is deep enough to shelter you from the wind but shallow enough to catch the midday sun, you can glory in its full, hot, dizzy blaze. Swags also offer shelter from sound and sight; all is sky and silence, gently punctuated by a cloud or the buzz of a bumblebee. Once you're lying in a swag you feel insulated from the world, and in our games the seeker often found the hiders in a state of calm reverie rather than expectant excitement. If, in a moment of extreme anxiety, I was ever advised to mentally retreat to my happy place, I would unhesitatingly choose to imagine myself just there, in one of those dips, waiting to be found but not caring if I was or not, as cosy as fluff in a belly button.

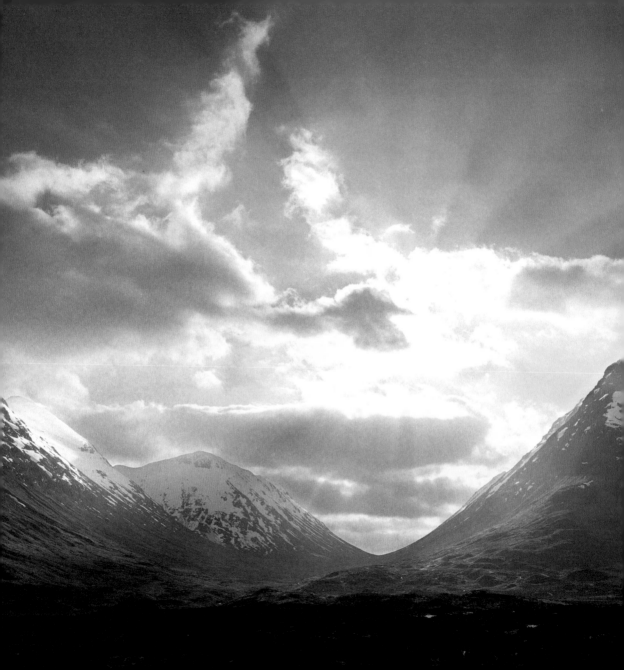

HIGHLANDS

With crampons strapped to my boots and an ice axe in my hand I should have felt more like a mountaineer than an invalid, but on hands and knees, legs burning and shaky, hauling myself slowly up a steep, snow-covered slope and stopping frequently to catch my breath, my body viscerally broadcast its message: I still wasn't well.

My original plan had been to make the journey to Scotland in February, part of a carefully organised schedule that slotted field trips among school holidays and other home and work commitments, but then the van's gearbox broke beyond repair and I was hit by the worst flu I've ever had. For weeks the van sat in the garage waiting for a donor gearbox, and I lay in bed waiting to feel better, or die. In feverish dreams I saw gears chewing hungrily at each other, grinding and mashing. In these dreams I knew that if I could only put them right and get them to mesh smoothly I'd also be able to recover, my congested lungs and the van's crumbling gearbox becoming conflated by delirium into a single, mechanical problem that I felt I should be able to solve, but couldn't. Scotland would have to wait.

Things slowly improved. A course of antibiotics for the chest infection that followed my flu and a reconditioned gearbox fetched from Germany finally put us both back on track, and one month later than planned I took to the road for the far North.

Strong winds buffeted the van all the way up the motorway, making for an exhaustingly twitchy journey. But as I drove into the Cairngorms I got my first view of the snow-capped peaks I'd been nervously looking for since crossing the border. Of the twenty or so features I was hoping to photograph, six or seven were snow and ice formations, and the thought that I might have missed my chance to find them had been hanging over me. But now I felt calmer and so did the wind. Silver birches stood slender and white as strips of torn paper beside the road, their outer branches the colour of hennaed hair, shining in the afternoon sun against dark clouds that clotted on the horizon. It was good light, epic light. The kind of light that taunts you for not taking pictures and then disappears by the time you've parked and got your camera out.

It was the following day that I found myself climbing up a ridge to the west of Cairn Gorm called 'Fiacaill a'Choire Chais' (this translates to 'tooth of the steep corrie') and I realised that the illness and weeks of convalescing had left me weaker than I'd thought. The next few days were going to be a hard slog. Luckily I had expert help from mountain guides Graeme, Liam and, later, Ian, who made sure I got to where I needed to and did so safely. Graeme was with me that first day and when, as I struggled up Cairn Gorm with the wind firing what felt like needles of ice into my face, I asked him why he wasn't cowering behind his hood like me, he merrily replied, 'I suppose it's because I know it can get much worse'.

I heard what sounded like a distant train one afternoon near Loch Avon and turned to see an avalanche spread a greyish smear down a perfect white slope. The temperature was rising, said Liam, and he explained that as the snowpack becomes wetter and heavier, the bonds between the layers of snow weaken, allowing the upper slab to slip down. Ptarmigan on the hills were feeling the onset of spring too, the males strutting around and bickering in their strange, croaking voices. But the spring-like weather was not good news for the snow and ice features and, hoping temperatures would drop in a few days, I left the Cairngorms to look for peak shapes in the Grey Corries.

Liam and I walked along Lairig Leacach the next day in t-shirts, basking in the sun. Winter definitely seemed to be on the wane. On either side of the trail rose a variety pack of peaks. Here stobs, sgurrs, mealls and beinns were on display side-by-side as though in a catalogue. From the bothy where we stopped to eat lunch I could look from one peak to the other and try to discern their essential characters. What was it about the stobs that made them different from the sgurrs? Why were the mealls so definitely not beinns? I wondered whether there was a general consensus among those who knew the Scottish landscape even if the qualities of each peak type were subjective or difficult to articulate. To the south-west, Stob Ban, pointed and thorn-like, looked every inch the archetype of stob-ness. 'From here it looks like a classic stob shape,' agreed Liam, 'but from the other side it's not so clear.'

That night I sketched mountain profiles in my notebook and traced contour lines on my maps, trying to pin down the peak names to neat definitions, but they wouldn't stick. In the end I gave up and let them be. Later in the trip, I noticed that I could often guess the name of a peak from its shape, though I wasn't ever certain. Somehow, the names had settled into place once I'd stopped chasing them and, like resting butterflies, they might stay put so long as I didn't bother them.

It was still dark when Liam and I started to walk from Glencoe to the Aonach Eagach ridge the next morning. For the first hour we both walked in the small pools of light from our head-torches. We followed a steep path that became a stream and then opened out onto scree and snow. As we climbed, the sky tinted grey, then blue, and the peaks began to glow orange like heated metal. I switched off my torch and suddenly moved from the tunnel vision of a narrow beam of light to a stunning panorama, as though I'd been peering through a keyhole and had now flung not just the door open but the whole wall. I stopped to catch my breath and turned to look back over the valley. At that moment, away to the south, a meteor streaked through the sky, burning bright white to blue and then green before fading. I waited for Liam, who was a little way behind me on the trail. 'Did you just . . . ?' he started to ask as he approached, but he didn't finish when he noticed I was already grinning and nodding. Amazingly he had turned and seen the light too, though it made no noise and there was no apparent reason for either of us to look in that direction. It felt like an omen of good fortune.

It had been a long walk, but at the summit I was encouraged by the feeling of energy reserves in my legs. The early start had got us to the arête just as the sun had started to glint and shimmer on its sinuous blade. As I started to set up the camera and make images, I registered a change in the messages from my body. For the first time in weeks I felt well. Behind us to the north, Ben Nevis had shed the clouds it wears for an average of 315 days of the year and it stood bare and magnificent against the morning sky. Everything seemed to be rousing from sleep.

On the descent we could feel the change in the snowpack. What had been hard, brittle névé on the way up was softening in the sun, becoming granular, even slushy. As we reached the treeline we were congratulated by chaffinches and wreathed in the sunlight that spilled over the hillside. Further down the track we spotted a group of red deer either waking up or stopping for a rest in a hollow a little way down the hill.

We entered the cafe like labourers who had accomplished a tough day's work while the rest of the world slept in soft beds. Glowing with a sense of self-satisfaction we ordered cooked breakfasts that seemed our rightful reward, and as we ate we talked of past labours and the well-deserved breakfasts that had followed them.

Those days in the mountains were difficult, but productive. In the evenings I had barely enough energy to cook a meal and make some notes before crashing out. But as the days went by I found some of my strength returning and felt glad of it. I was glad of the growing pile of exposed film, too. It represented tangible progress, hard won.

COIRE /ˈkɔre/

RELATED TERMS: corrie, cwm, coombe

OS: NH 999 017

Coire

Used in different regions, 'coire', 'corrie', 'cwm', 'coombe' and 'cirque' are all words for a glacially eroded basin with an amphitheatre-like shape that forms the head (i.e. upper end) of a valley. These features typically sit into the sides of mountains, where glaciers once formed and began their journey downhill, gouging the rock face as they went. Where the glaciers are extant they fill the basin, and where there are no glaciers, as in the UK, the dip left behind may contain a lake. This concurrence of cirque and lake, coire and loch, cwm and llyn, coombe and tarn is common wherever glaciers have been. Also present in and around these features are ridges called 'moraines' made up of material once held in and transported by the glacier.

'Corrie' is most commonly used in Scotland and derives from the Gaelic 'coire'. In Wales the usual term is 'cwm' though in South Wales this word is also used generically for all valleys. England has 'coombe' (sometimes 'combe') but as in Wales the meaning is extended and can be one without a river or stream. The French word *'cirque'* (meaning 'circus') has become the most common international term.

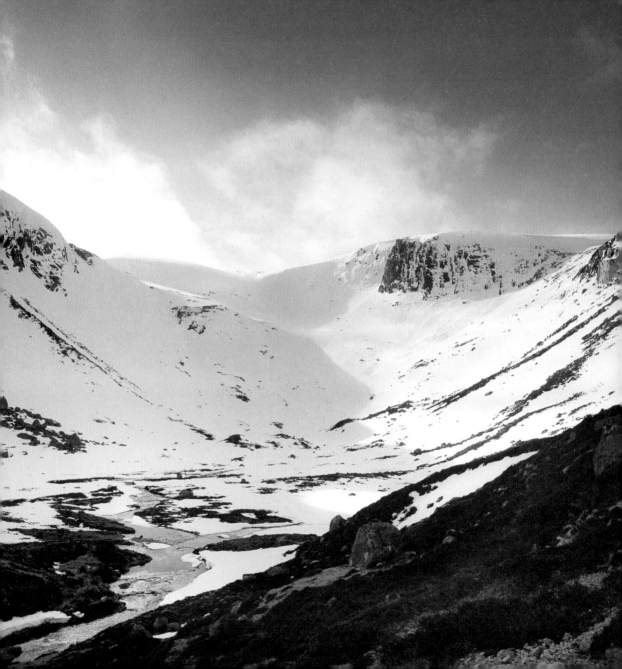

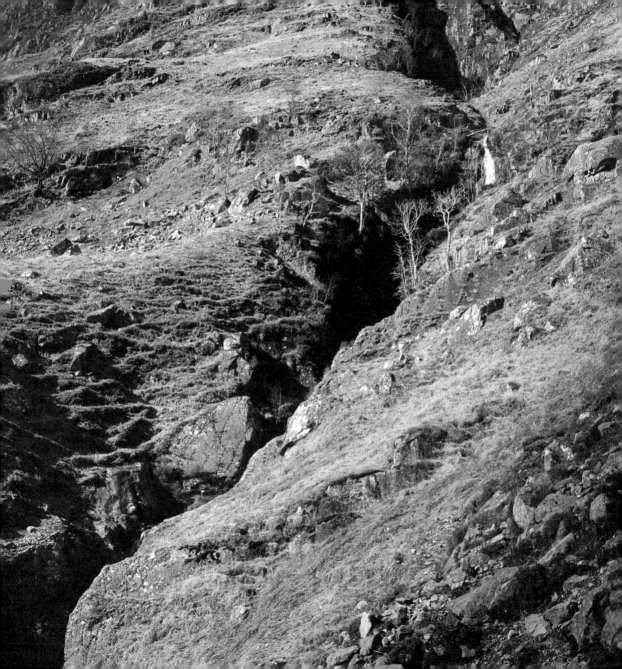

Couloir

Running water carves these v-shaped clefts into the mountainside. Fissured and narrow, they are defined along their edges by sharp, sheer rock. The river or stream responsible for a couloir may have long since dried up, for instance if it was fed by glacial meltwater, or may only flow seasonally depending on rainfall or meltwater from snowfall. When they fill with snow and ice in the winter, these features live up to their French name by providing passage up for mountain climbers and passage down for the braver skiers and snowboarders.

In Scotland, couloirs are mostly called 'gullies' as in Tower Gully and Gardyloo Gully on Ben Nevis, which, like many high, north-facing gullies, hold snow for most of the year.

As with *jus* instead of gravy and *salon* instead of hairdresser's, it might seem like pretension to use a French word where a perfectly good English one exists, but there are two points to make about that. First, the Scottish usage notwithstanding, 'couloir' is a word specific to gullies in mountainsides. Secondly, the word 'gully' seems to derive from the French '*goulet*', for 'bottleneck', so it's French either way.

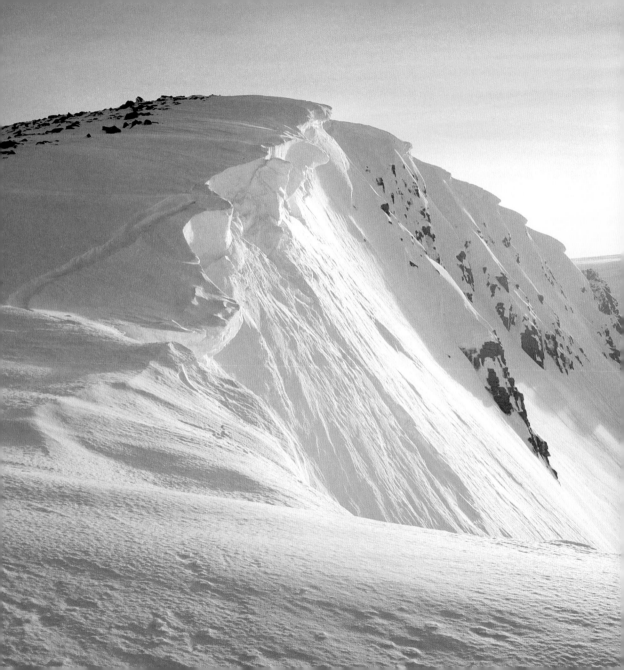

CORNICE /ˈkɔːnɪs/

RELATED TERM: arête

OS: NH 998 032

Cornice

Resembling the curling edges of huge frozen waves, cornices are shelves of compacted snow that project from the leeward edges of mountain ridges. As with waves, the wind plays a key role in their formation, but for a long time this role was misunderstood.

It was thought that these shapes were made by the accumulation of snow on their leeward face, and that the snow was transported there by eddies swirling over the ridge. Although this theory is still offered by many sources, fieldwork in the 1980s by researchers from Hokkaido University's Institute of Low Temperature Science and Japan's National Institute of Polar Research produced very strong evidence against it. The researchers established a timeline in the snow by periodically spraying the surface with a coloured dye so that when the cornice was dissected, the growth pattern would be visible like rings in a tree. Sections through the slab showed very closely spaced rings on the leeward edge, indicating very little accumulation between layers of dye, while on the upper face of the slab the rings were spaced much further apart. The researchers concluded that cornices grow when snow is deposited on top of a horizontal slab that is extended leeward by the wind until it cantilevers over the edge of a ridge. The wave-like curves, which may have suggested the involvement of eddying currents, are a product of gravity and the snow's plasticity.

Snow slabs can bend a little but as the cornice's mass increases, or temperatures rise, partial or complete collapse is inevitable. It's common for a collapse to take a large slab of snow from the windward side of the ridge as well as the cornice itself, and falling cornices can trigger avalanches that can fan out along a slope at angles of thirty degrees. Whether you're beside or below them, it's wise to give cornices a wide berth.

ARÊTE /ə-ˈrāt/

RELATED TERMS: coire, cornice, druim and aonach

OS: NN 141 583

Arête

.

Left between the coires scooped out by neighbouring glaciers are steep-sided ridges, weathered and honed to knife-like edges. They typically fan out from summits or run between peaks, providing a narrow and precipitous route for the surefooted (or foolhardy). The French word '*arête*' is used internationally for these ridges; its translation into English offers 'edge' and 'fish-bone', two meanings that nicely span geometric and figurative qualities.

In Scotland, features like these are usually called either 'druim' or 'aonach'. In Gaelic both words mean 'ridge' but 'druim', with its other meanings 'back' and 'keel (of a boat)', best evokes the classic arête shape. 'Aonach' can mean 'steep place' and also 'panting' or 'breathless', a meaning which describes my state for much of the time I spent in the Scottish Highlands.

Elsewhere in Britain these sharp ridges are known by a number of different names, including 'edge', as in Striding Edge in the Lake District, and 'crib' (Welsh for 'comb'), as in Crib Goch in Snowdonia.

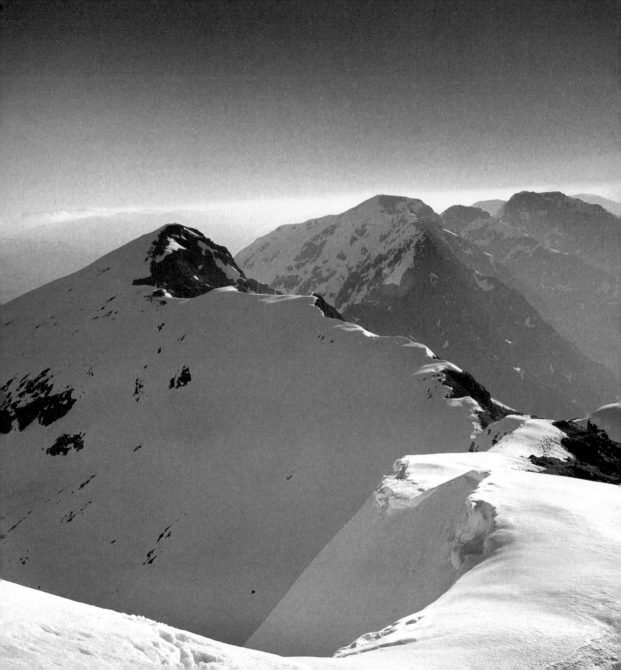

Fraon

A fraon offers sanctuary from the elements, a place to seek temporary refuge from the rain, wind and snow, to hunker down and wait for the worst to blow over. In foul weather, finding a fraon under an overhanging cliff or beneath a mass of boulders might well keep you alive, if not comfortable. Many such places have been used as shelters for hundreds, even thousands, of years and over time short-term tenants may have improvised additions to the meagre facilities: a rough, stone windbreak at the entrance, perhaps, or a level bit of ground to lie on.

The pile of snow in the entrance of the shelter pictured opposite seems to be a natural formation, a result of the trapped air inside the space pushing against the wind to form eddies in which drifting snow collects. In Scotland, 'snow wreath' was once a more common, and more lyrical, expression for a snow drift, so in this case a snow wreath has been laid at the doorstep of the fraon.

'Fraon' is Gaelic, but seems to be very seldom used. I found it in a couple of early eighteenth-century Gaelic dictionaries, but only because I was specifically looking for a word for this kind of feature. Its meaning – a place of shelter in the mountains, or in a rock – is nicely specific and certainly useful, but nevertheless I've not found it on any current maps. I think 'fraon' has great potential for reintroduction into use, especially if you consider the wider meaning of 'a place which offers shelter only marginally more comfortable than exposure'.

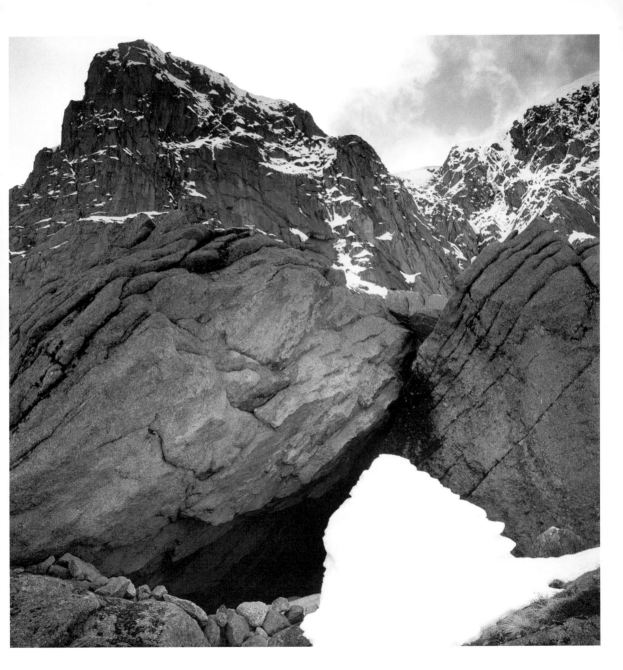

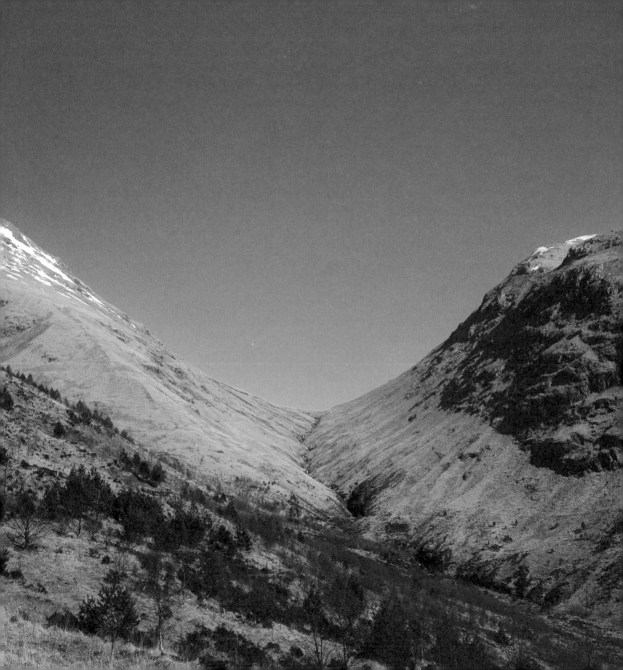

Làirig and Bealach

A combination of geometry and utility defines mountain passes. For the sake of utility they tend to cross at the lowest point between peaks, and by virtue of geometry this can also be the highest point on the pass. In this way they describe a geometric form called a 'saddle surface' or 'hyperbolic paraboloid', which curves up in one direction and down in the other.

Though the Gaelic words 'làirig' and 'bealach' are often used interchangeably to mean 'pass', where a distinction is made it's that the làirig is the pass itself, while the bealach is the gap in the mountain range through which the pass runs.

Real and imagined passes have led to refuge and escape and been paths of transformation as well as transportation. Hidden beyond a fictional pass in the 1933 novel *Lost Horizon* is Shangri-La, a place of harmonious enlightenment where the ageing process slowed to a crawl. '*La*' is Tibetan for 'pass', suggesting that the path is the destination, a sentiment that might have been beyond the subtext of the original book but which accords well with the way Shangri-La has come to represent an unattainable earthly paradise.

Sir Walter Scott's folk hero (and cattle thief) Rob Roy MacGregor's intent was not enlightenment when he drove his rustled herds over the Bealach nam Bò ('pass of the cattle'), but once through the pass and concealed in the mosses beside Loch Katrine (*see* MOSS) the cows were as safe from detection by their former owners as they might have been in the furthest reaches of Tibet. Another 'pass of the cattle', the Bealach na Bà, which rises from sea level to 626 metres in around six miles of 1:5 gradients and hairpin turns, has become a place of pilgrimage for cyclists, a group for whom a higher state of being is more or less synonymous with a state of being higher.

Beinn, Sgurr, Stob, Meall, Stùc, Stòr

The Gaelic language differentiates between several kinds of peak. This is no surprise, given the variety of mountain features in the Highlands and the benefit of being able to tell them apart. However, the typology is fuzzy and often confusing: a beinn might look like a stob, a stob might look like a stùc and a stùc might look like a sgurr. There are differences between these peaks – some subtle, some obvious – but their characteristics are spread along a complex continuum that involves factors of sharpness, shape, rockiness and relation to other peaks. So, while it's possible to look at a peak and guess from its smooth, tall, conical shape that it's a stob, you wouldn't always be right. Having said that, some peaks have a kind of stob-iness or sgurr-iness that is hard to define, and some types are relatively easy to distinguish – the shapeless mound of a meall looks very different from the sharp pinnacles of a stòr, for example.

Here is a rough and ready guide to six kinds of peak:

BEINN /beiNʲ/: Often anglicised to 'ben'. Mountain or high hill. Other meanings include: 1. Head; 2. Top.

SGURR /sguːR/: A large, sharp, conical hill.

STOB /sdɔb/: A point or pinnacle. Other meanings include: 1. Pointed stick or stake; 2. Thorn; 3. Remaining stump of anything broken or cut.

MEALL /mjauL/: A rounded heap or lump, a shapeless hill. Can be applied to any heap of matter.

STÙC /stuːxg/: A small hill jutting out from a larger one. A cliff or a steep, conical rock. Other meanings include: 1. Horn; 2. Lump.

STÒR /sdɔːr/: A steep, high cliff or jutting pinnacle. Other meanings include: 1. A broken tooth.

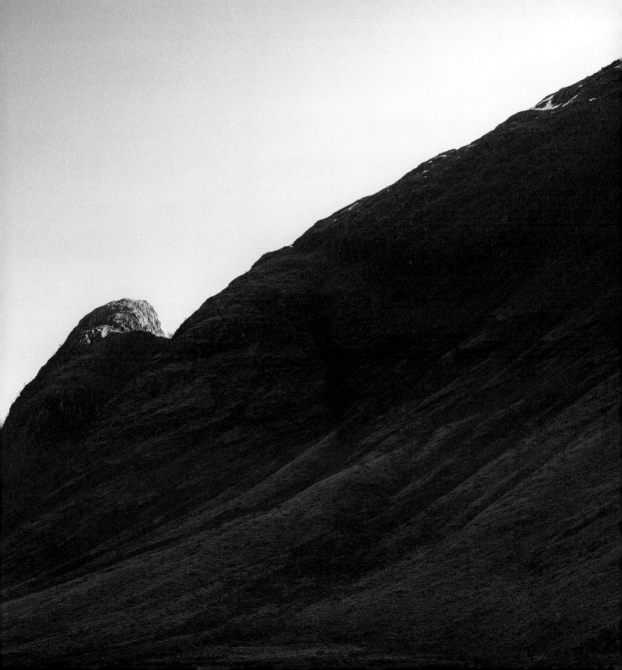

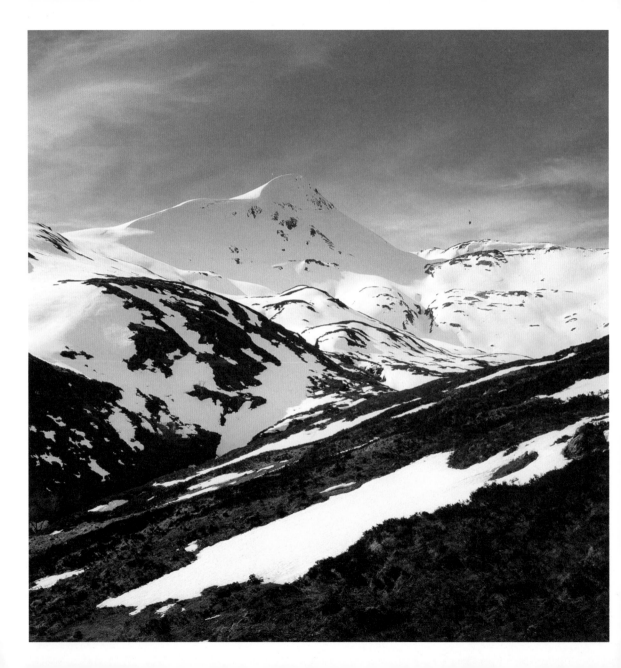

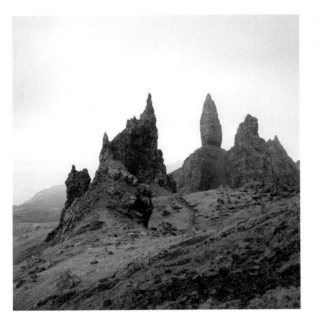

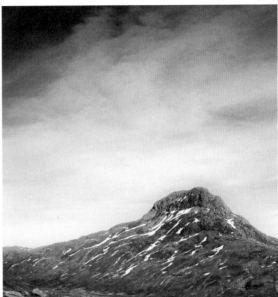

◁ STOB /sdɔb/ △ STÒR /sdɔːr/ ▷ SGURR /sguːR/

OS: NN 267 723 OS: NG 501 589 OS: NN 290 747

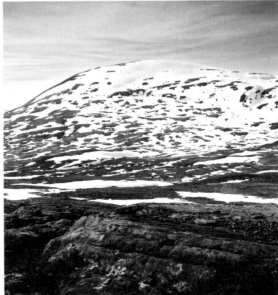

▷ MEALL /mjauL/

OS: NN 280 705

Névé

Snow is complicated. It can be soft as gossamer or hard as nails, it can shelter you from the elements or crush and entomb you, it can stick like glue or flow like a river: all depending on tiny changes in its structure and temperature. Névé, at least, is the kind of snow you can rely on: it's snow that has thawed and refrozen, maybe more than once, making it stable and solid. Mountaineers like it because it's easy-going, crampons give a good purchase and you save energy when you're not up to your knees in powder; skiers hate it because they slip on it and it hurts when you fall.

The word is Swiss French, one of many that made its way into the international vocabulary of the mountains during the nineteenth-century infancy of recreational climbing. Before this time, mountains were climbed as a means to an end, by hunters in search of their quarry, by travellers in search of passes or by the faithful in search of their gods. Ascending a peak for its own sake was a practice that developed in the Age of Enlightenment, when new rational enquiry overwhelmed old superstitions and the great amateur scientists of the era, with money and time on their hands, went searching for the new god of knowledge. The Alps, and the area around Chamonix in particular, became the cradle of mountaineering and the cross-cultural mix of the first 'Alpinists' can be seen in the hodgepodge of European languages that make up mountain-climbing terminology.

Névé that survives a year without melting becomes 'firn' (Swiss-German for 'last year's') and as this firn ages and becomes yet more compacted by the snowfall of subsequent years, it transforms into blue, glacial ice.

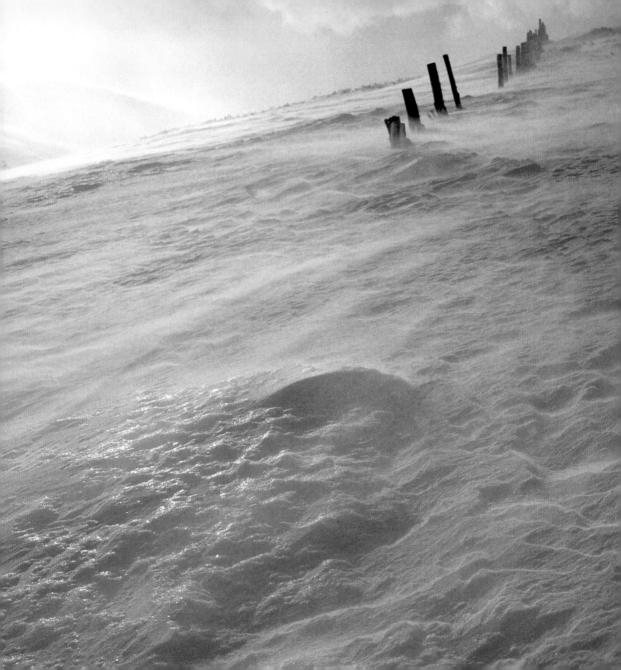

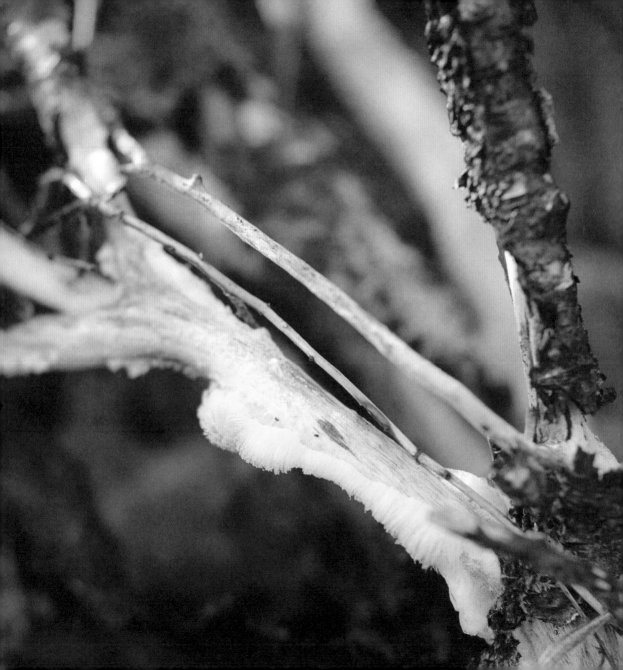

Haareis

I wasn't looking for haareis. I didn't know what it was when I found it and I wasn't too sure even afterwards what it was I'd found. The white tufts on a dead birch branch looked at first like mould or a clump of fibreglass, and when I touched it, I was surprised to find that it melted. It didn't look like a form that could possibly be made from ice. Could it be a very delicate fungus? A little research proved not only that I was wrong to underestimate the myriad forms of frozen water but also that I wasn't the first to suspect an organic component to this rare phenomenon.

In 1918 the German meteorologist and geologist Dr Alfred Wegener, who would later become known for his work on plate tectonics, published a short paper called 'Haareis auf Morschem Holz' ('Hair Ice on Rotten Wood'). He described fine strands of ice that seemed to grow from dead wood in freezing conditions and speculated that a 'mould-like fungus' might be the scaffold for these structures.

Similar, but coarser, forms called 'needle ice' can be found growing from the soil due to a process called 'ice segregation', whereby ice crystals growing at the surface of a porous material draw out further water by capillary action. This, in turn, freezes and over time the ice builds into long strands.

For many years after Wegener's paper the fungus theory was disputed, with most scientists contending that ice segregation was enough to explain the formation of haareis. However, research published ninety years after Wegener's seems to support his theory. Scientists at Bern University took wood known to produce haareis and exposed some pieces to boiling water or fungicide while others were left untreated. None of the treated pieces later produced haareis, while the untreated did.

Rime

This build-up of feathery, white frost forms at temperatures just below freezing in high winds when droplets of water in fog or low cloud hit cold surfaces. Rime always grows into the wind and can produce spectacular and elaborate structures. Rock outcrops on high mountains can develop icy plumage as fine as an ostrich, trees buckle and stoop under the weight of their ornate encrustations like decrepit kings and queens wearing all their crown jewels at once.

Hoar frost, which can look similar to rime in its early stages but never gets as baroque, is formed when water vapour freezes directly onto a surface rather than condensing into droplets and then freezing.

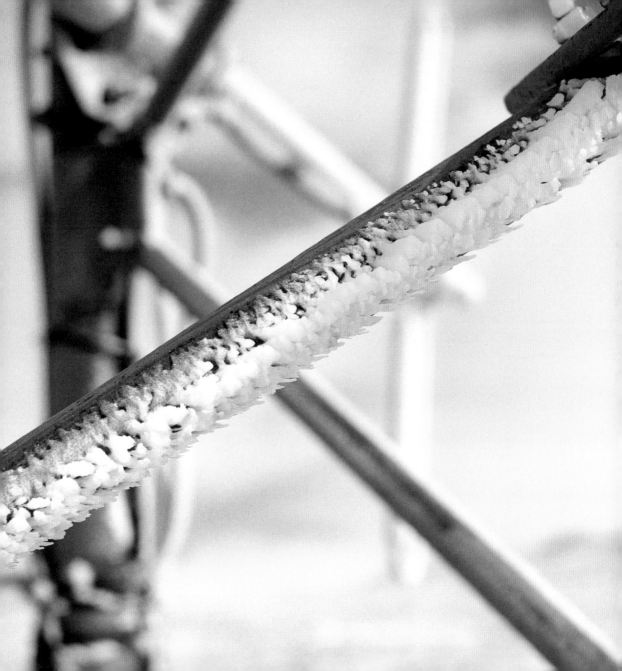

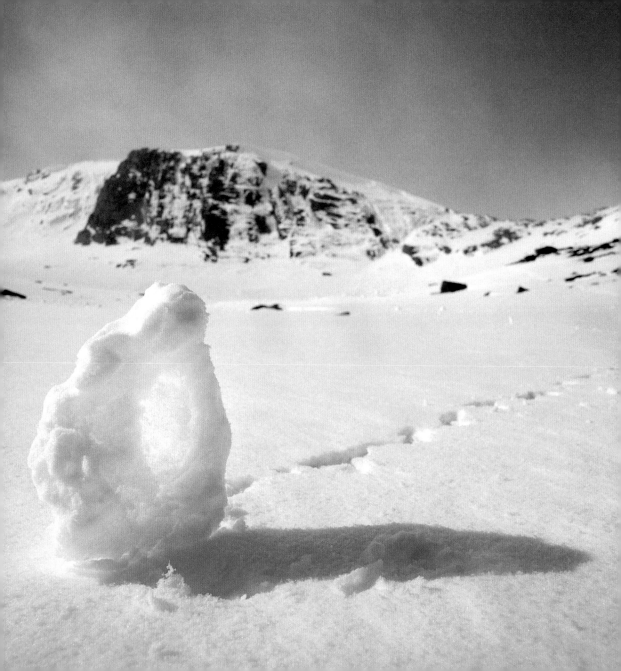

Sunwheel

If you walk on a slope of just the right incline, covered with snow of just the right consistency and depth, you will find that the clumps of snow falling from your boots scud away downhill, accumulating more snow as they go. Most of these lumps will topple and fall quickly, but some – the rare ones – will stay upright and, as they roll and grow, become discs of snow. Even rarer are discs that aren't begun by a footfall but start as a patch of melting surface snow that refreezes into small pellets of ice. Moved about by the wind, these icy pellets stick together and stick to more snow, and if they get heavy enough and round enough they begin to roll on the wind or downhill. The resulting formations are known by a number of names, my favourite of which is 'sunwheel'.

A similar feature called a 'snow-roller' builds from a length of icy snow into the shape of a Swiss roll.

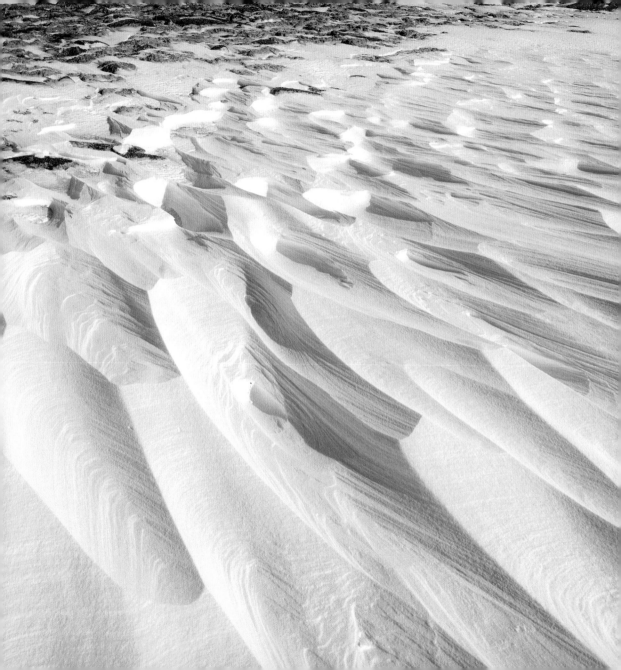

Sastrugi

The wind pushes fresh snowfall around like a sculptor kneading clay. It gets piled here and there in drifts, or settles over a field where it will get packed down under its own weight and cohere. Only once it has consolidated can it be carved into something as fine and dramatic as sastrugi.

These ripples and grooves sculpted in snow are unmistakably aeolian. They make visible the great pulling masses of air that run over the earth, the fluttering, buffeting currents and the tearing, renting gusts, always going somewhere and evangelising for their direction. The traces of these winds are recorded in beautiful detail in sastrugi; you feel that if you look closely enough you might read them breath by breath along the length of these delicate troughs so like the marks of a gouge.

'Zastrugi' is a Russian word with several meanings such as the splintering of planed wood against the grain, the undercut bank of a stream and, metaphorically, a state of anxiety.

As you might expect, Inuit languages have their own set of words for these features and define several variations, including '*tumarinyiq*' for shallow ripples, '*kaioqlaq*' for larger-shaped blocks, and '*mapsuk*' where the base of *kaioqlaq* has eroded faster than the upper layers, leaving an anvil-like overhang.

The desert equivalent of sastrugi are called 'yardangs'. These are carved from rock by fine particles of sand carried on the wind. This natural sand-blasting of the bedrock isolates steep-faced blocks that are aligned to present their narrowest edge to the prevailing winds. Some of these blocks can be huge: it's thought the Great Sphinx may originally have formed as a yardang before being carved and augmented.

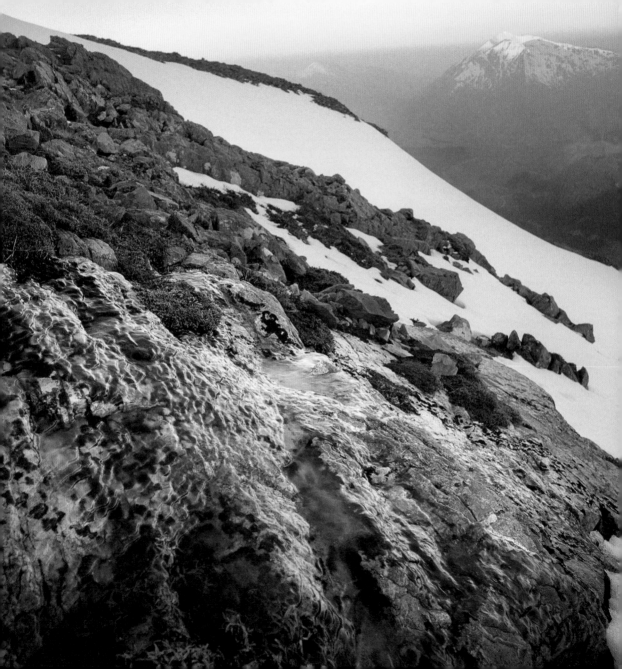

Verglas

This is a clear glaze of ice that forms when water flows over objects that are cold enough to freeze it, or falls as a supercooled liquid that crystallises into ice when it meets a solid object. It's used in mountaineering to refer to a thin, practically invisible coating of ice on rocks that makes them treacherously slippery. In northern Labrador I once saw a forest of crystal chandeliers that turned out to be a stand of spruce that had been completely covered in verglas. When the wind stirred their branches they rang like bells.

The word is from the Old French 'verre' ('glass') + 'glaz' ('ice'). To English speakers, then, the glassy quality of this phenomenon is now conveyed by the *wrong* bit of the word, and in that sense it's accidentally evocative.

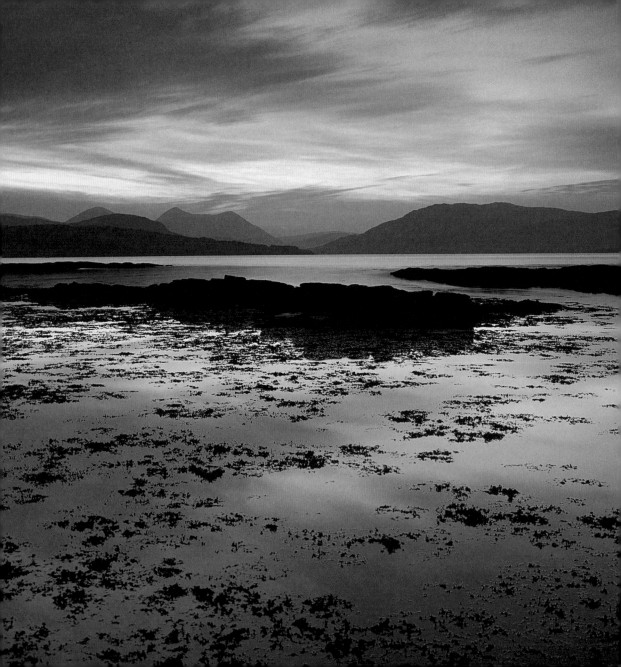

LOWLANDS

After four days in the mountains I set off for the Western Isles, in search of peat and sand and sea. The road from Fort William to the Kyle of Lochalsh cut inland towards Spean Bridge before turning north across the valley, where it offered a view back towards the Nevis Range. The mountains that had looked so overbearing from the Aonach Eagach now looked timid and cowed beneath a raging, roiling sky.

Feeling the need to make progress, I resolved not to stop for every possible image, but I was tortured by the ones I drove past. In a football field in Invergarry I saw a man armed with a shovel on a mobility scooter who appeared to be tilting at molehills. He would have made a wonderful Don Quixote but I hesitated, and the moment escaped into the rear-view mirror.

I stopped for the night just outside Broadford on Skye. The grey clouds had cleared and the evening looked so promising I searched my maps for something nearby to photograph. Just offshore a couple of sgeirs were marked, and since the tide was out, I gathered my gear and set off. By the time I had walked to the beach, the light was very low but still beautiful, so I set up some long exposures looking out across the water. Watching me with interest, a solitary seal tracked across the scene leaving a faint, ghostly trail on some of the images.

A storm rose that night and for the next five days on Skye, Harris and Lewis, the wind was an almost constant companion. Sometimes it was mischievous, as in Portree, where it snatched an elderly gent's cap and tumbled it down the road (I brought it back to its owner but I found his hands were too full of shopping bags to take it so I asked if I should 'put it back on top?'; 'Aye, why not?' he said, and leaned to offer his bald pate as if for benediction). Sometimes it was malevolent: at the Storr on Skye, a moment's inattention was enough time for a gust to lift my camera bag and pitch it off the hillside (I clambered down to fetch it, seething at my carelessnesss, expecting to find a mess of broken glass and useless gear, but amazingly nothing was damaged – returning hats evidently brings good karma).

The next day's early-morning ferry from Skye to Harris smelled of toast and diesel. During

the previous night the van had been pitched and tossed by strong gusts like a small boat on high seas; by contrast the ferry, with its deep, thrumming engines and its gentle motion on the swell, felt more like a big, slow animal as it left the harbour at Uig and sailed into the Minch. Once out of sight of land, low white cloud covered us in a dome that made the rest of the world seem absent. We could have been making any journey, or none at all, but for the evidence of a small computer screen mounted in the observation lounge that was plotting our position on a map. Periodically, the screen refreshed to show islands passing invisibly on either side. The coastline of Harris, when it appeared on-screen, was a fractal pattern of water and land. The non-virtual Harris appeared some time later like a faint stain on the uncertain horizon, gaining solidity and colour as we approached the little ferry port at Tarbert. An announcement, first in Gaelic and then in English, asked drivers to return to their vehicles, and as the ship manoeuvred to enter its temporary harbour we prepared to leave ours.

From Tarbert I drove first to Stornoway and then northwards towards Port of Ness. The weather forecast was looking grim and my kit was in need of a good clean and dry, so the relative comfort of four walls and heating was an attractive prospect. I'd booked in to a bunkhouse and, as

March is a bit early in the season for walkers, I had the place to myself. After removing a week's worth of grime from my camera gear, I spread out maps, books and equipment to dry and indulged in some TV.

When the novelty of the afternoon film wore off I walked from the bunkhouse back to the main road, and across it to the moorland on the other side. The wind was impatiently dragging peat smoke away from the chimneys, only the occasional sniff of it reached me, but even if I hadn't been able to smell any, the black turfs piled like giant hedgehogs in every other yard identified it. Peat is still cut on Harris and Lewis, each village has its allocated area and although most houses are now centrally heated, peat provides some with a cheap source of warmth. The peat fire in the pub that evening was made slightly surreal by the rhinestone-encrusted sombrero hung above its mantelpiece. The rough walls of what might recently have been a cattle shed were pasted with posters for Bacardi and Captain Morgan spiced rum, but the drinkers at the bar were sticking to pints. I'd thought of seeking out some local knowledge about the peat terms I was looking for, but my nerve failed, so instead I sat with a beer by the hearth and earwigged on their good-natured profanity, feeling very much an outsider.

The following day, the wind jostled and shoved me across a peat bog near the Butt of Lewis until

I felt like I was inside a panicky, invisible crowd, despite being many miles from the nearest person. Acting the officious security guard, it slammed into me as I tried to set up my tripod – 'Oi, you can't do that here – shove off!' The track I was following over the moors became less and less certain, in places it had sunk into the peat and in one such dip old wheels had been laid as an improvised causeway: the dead paving the way for the living.

Propelled on the unwelcoming wind, the light drizzle that was falling gained the soaking power of a full monsoon and I tried to find shelter in an abandoned shieling, but the wind followed me. Carved on the walls were the names of others who'd looked for shelter, not all of them from the wind. 'Katie 4 Aly', and more like them, suggested lovers escaping the eyes of their families. It would have been a fine venue for a tryst in better weather. Shielings, the summer pastures, were the domain of women; it was they who tended the animals while the men stayed in the villages and looked to other work. As I understand it, the men would pay visits but then return to the village. This arrangement was more like a courtship than a marriage and I wonder whether the semi-separation gave husbands and wives a welcome taste of romance, or gave the women a welcome taste of self-determination. Perhaps the shielings have always been trysting places.

Lewis marked the furthest reach of my journey. I had more work to do but it was all on the way back, and though we'd been in touch most days I was missing my family and was glad to be homeward bound. When I drove off the ferry onto Skye, a small and not fully acknowledged anxiety was lifted when I realised that there was no more water to cross and only a long, long road between me and my wife and kids.

Shieling

The seasonal movement of livestock continues in parts of Britain, but the accompanying movement of populations, called transhumance, has nearly died out. It still happens on a small scale in rural Wales and on the Western Isles, where the word 'shieling' is used to refer to both the summer pasture and the shelters that stand there. Modern shacks of corrugated iron or pitch-painted timber might provide a resting place for a dwindling few, but the ruined brick settlements they stand beside were once like summer villages. Shielings now stand empty through winter and summer but they are often visited in nostalgia. Published in 1913, *Reminiscences of Old Scots Folk* by T. Ratcliffe Barnett was already mourning the end of shieling life with more than a hint of rose-tinting.

All through the livelong day the women were busy on the green sward at the burnside churning the butter in the kirns, and pressing the cheeses between the heavy stones. And the little barefooted bairns, free from all the restraints of the dominie, ran about the sunny braes, gathering the blaeberry or the luscious cloudberry higher up, and guddling with bare arms in the burns for the bonny speckled trout which were so sweet to the taste at supper-time . . . Such was the happy, romantic life of the summer shielings. It is all gone now. For the glens are empty, and the little houses high up on the hills are lying in heaps of grey ruins with nettles and briers growing all about them in the silence of the grassy banks by the mountain stream.

Caochan

Water flows, trickles and percolates through the peat bogs of Lewis under many guises. It flows out from lochs as a '*feadan*', the same name as is given to the bagpipes' chanter (through which the melody flows), it cuts twisting veins through the peat and is named '*feith*': Gaelic for 'sinew'. When it pools it might be a deep *linne*, a shallow *glumag* or a boggy *botann*. Where a stream runs in a channel so slender and overgrown that its presence is only given away by the gentle purl of running water it takes its name from the Gaelic for that murmuring sound: 'caochan', a word that also describes the bubbling sound of fermenting worts and the eddying of air and water.

Peat Hag

Broken moorland, bogland pools, awkward mounds of turf, or the wounds and scars of peat-cutting are all 'hags'. The word derives from the Old Norse '*haggw*' meaning 'hew', a sense that has been preserved in dialect use in Scotland and northern England, where overgrown undergrowth might be 'hagged' rather than 'hacked'. We more readily think of hagglers slashing prices than brambles, but the word origin is the same. The crone-like profile cut into the hag pictured is a misdirection: that meaning of hag comes from '*hægtesse*', Old English for 'witch'.

Peat hags are made by man and nature alike. They can be left as remaindered pillars or wedges between the banks of cut turf, or mounds isolated by the rents of winter streams.

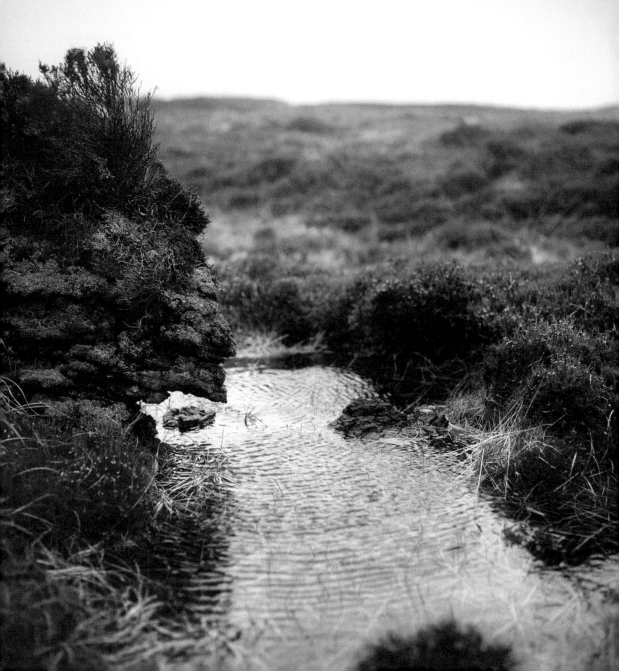

Maoim

Just inland from Cellar Head on the north-east coast of Lewis is an abandoned shieling marked on the map with the name 'Maoim'. The stream that runs beside the ruined huts shares the name, as does Tom Mòr na Maoime, the rising expanse of moorland that lies to the west. Maoim the place (pictured opposite) most likely takes its name from having been the site of a *maoim slèidhe*, which translates as either 'gush of water' or 'landslide': there's evidence of past movement in the peat nearby. Maoim has two meanings; 'outburst' ('*maoim sneachda*' means 'avalanche' – literally 'outburst of snow') and 'terror'. These two senses add nuance to each other, giving the physical event a psychological quality and vice versa.

Beyond the literal meaning, '*maoim sneachda*' might be understood as 'a panic of snow' or 'fearful snow' and the nature of the fearfulness is sudden terror rather than creeping dread. In the Inuit language there are two root words for fear: '*ilira*' and '*kappia*'. Barry Lopez defines them in his book *Arctic Dreams*, '*Ilira* is the fear that accompanies awe; *kappia* is the fear in the face of unpredictable violence. Watching a polar bear – *ilira*. Having to cross thin sea ice – *kappia*.' Walking on shifting snow – *maoim*.

'Maoim' is also used to describe a phenomenon that could well induce mild *ilira*. '*Rionnach maoim*' (which can be literally translated as 'mackerel panic') is the running over the land of shadows cast by fast-moving cumulus clouds. If this phrase is not intended to evoke the shimmer of a shoal of fish darting away from a cast net or a hunting seal I don't want to know, I'd rather assume it was and be wrong for ever.

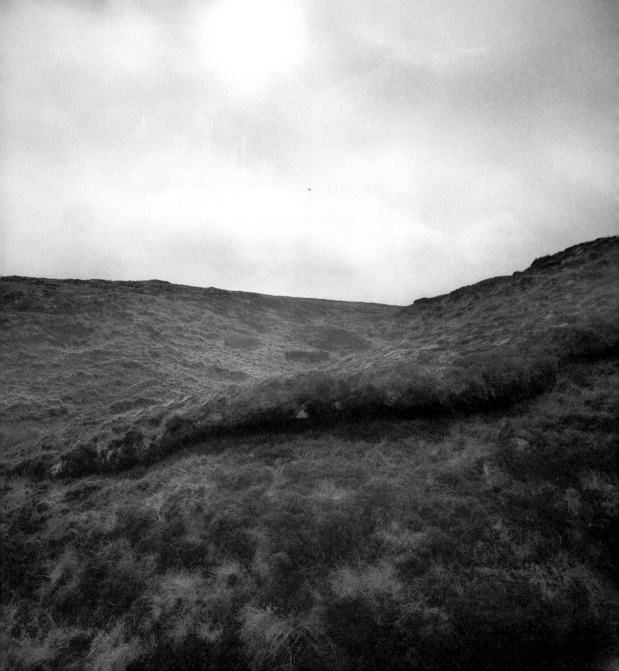

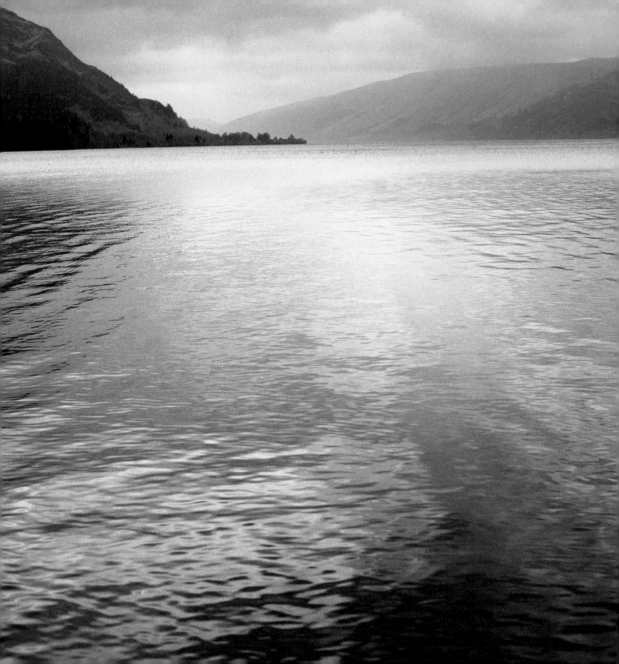

Loch and Lochan

There is a sharp but delicious terror that I associate with swimming in deep, dark water. It rises in me when I'm looking down into unmitigated blackness, my hands pulling down bubbles, bright as stars, into the void. All too clearly I can picture hulking creatures with teeth like scalpel blades and claws like meathooks, their milky, gloom-accustomed eyes tracking my silhouette on the surface, readying themselves to drag me into the abyss. I have scared myself silly a few times with this image, and had to stop and tread water and recast the monsters as something less terrifying before carrying on.

The two deepest lochs in Scotland, Loch Ness and Loch Morar, are each home to their own legendary monsters, Nessie and Morag respectively (names more befitting an elderly aunt than a primal terror). I suspect the monster comes from our deepest fears, while the branding, like my mid-swim recasting, is an attempt to reduce something awesome and terrible to something benign and harmless. In this case, naming diminishes the subject. Perhaps a more respectful relationship with nature includes an appreciation of the unfathomable, unknowable and unnameable.

The Scottish term 'loch' is not quite synonymous with 'lake'. It would be, but for the sea lochs, which are effectively inlets with channels out to the open water.

'Lochan' is the diminutive form of 'loch', but the line between what is big enough to be a loch and what is small enough to be a lochan is, appropriately enough, fluid.

73

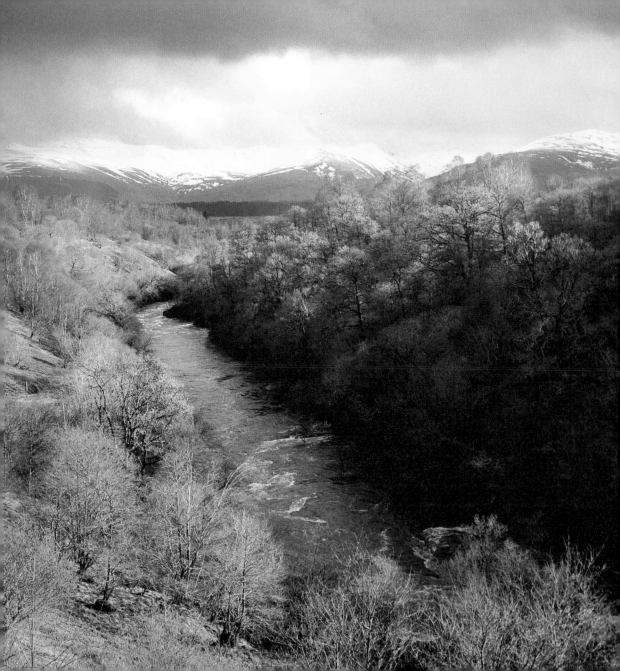

GLEN /glɛn/
RELATED TERMS: strath, glyn
OS: NN 186 835

Glen

From the Gaelic '*gleann*' ('valley'). A glen can be a depression between hills or, more typically, a deep, narrow river valley, often with wooded banks (straths, by comparison, are valleys that are wider and shallower). The huge number of whiskies named after the glens where they are made attests to the importance of fresh running water to distilling, and has, in turn, established the glen as a quintessential part of the Scottish landscape, real and imagined.

Glens and lochs are the landscape features most associated with Scotland, but the word 'glen' in particular has been transported by the Scottish diaspora to find use in new lands. The reach of adventurous Scots can be seen in the many glens marked on the maps of Canada, the USA, Australia and New Zealand. The word hasn't only marked the Scottish influence on maps, as the given name 'Glenn' found great popularity with Scottish expats (in the 1960s it was in the USA's top fifty boy's names, a position it has never reached on this side of the Atlantic). The unusual popularity of the name in Gothenburg, Sweden, derives from the influx of Scots that began after the Stuart rising in the early eighteenth century. In the 1980s the city's football team, IFK Göteborg, featured four Glenns, leading opposition sides to taunt '*Alla heter Glenn i Göteborg*' ('Everybody's called Glenn in Gothenburg'). The chant was swiftly and proudly adopted by Göteborg supporters and remains in use to this day.

Jackstraw

Named after a parlour game, this storm-felled tangle of trees presents a giant version of pick-up sticks for foresters. Jackstraws are most common at the edges of coniferous plantations, where closely planted trees are more exposed to winds. Proximity to other trees means that root structures can intertwine and this, more than the collision between the aerial parts of neighbouring trees, can cause large areas to fall like dominoes.

Jackstrawed timber is kept off the ground and it also tends to be loosely arranged, thus well-ventilated. As a result, the wood dries quickly and, if ignited, burns vigorously. Despite this added potential for forest fires, deliberate jackstrawing has been used in the US to protect saplings from elk and other browsing animals. The dead and decaying wood also provides a rich habitat for fungi, plants and animals, and though economic pressures and the instinct to tidy up may suggest otherwise, letting fallen logs lie is almost always the best thing to do.

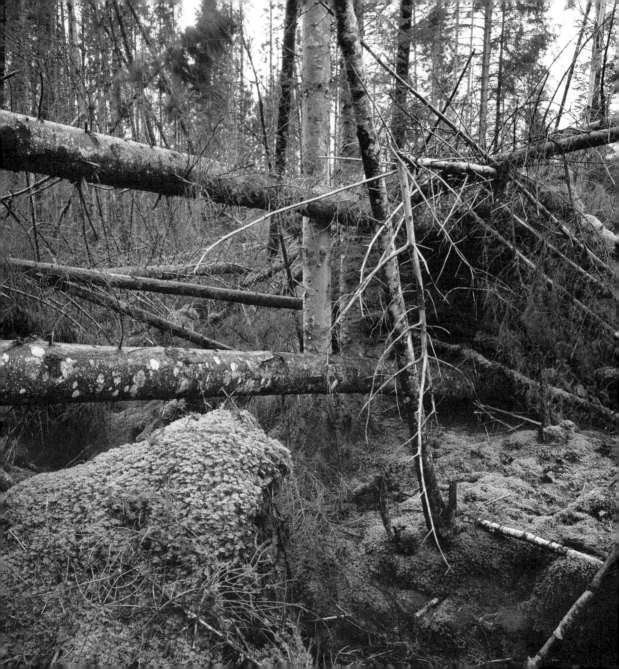

Witches Broom

At first sight, these clusters can resemble nests or, as their name suggests, the bound twigs of a traditional broom. Found in any woody plant, but most commonly birch, these are galls – a growth anomaly caused by an invasive organism. Whether it is a fungus, virus or insect, this organism disables a biochemical block on bud development, sending the tree's growth patterns haywire. As well as benefitting the culprit, this chaotic growth can provide a habitat for other species. North American red squirrels and northern flying squirrels are both known to make their dreys in witches brooms although this behaviour hasn't been recorded in the UK.

Our traditional wood-and-twig sweeping implement was historically known as a 'besom'. The twigs were usually cut from birch, heather or the flowering plant known as 'broom'. I always assumed that broom the plant got its name from broom the implement, but in fact the name of the plant came first, sharing a root in Old English with 'bramble'. 'Broom besoms' became simply 'brooms'. Had it gone another way it could easily have been 'birch besoms' becoming 'birches', in which case 'witches brooms' would be 'witches birches' and then we wouldn't know if it was the gall or the whole tree we were talking about.

MACHAIR /maxɪrʲ/

RELATED TERMS: meols, meall

OS: NB 349 518

Machair

The same white sands that make the beaches of the Western Isles look tropical on a hot summer's day are responsible for the rich meadows known as 'machairs'. Debris dumped into the sea by glaciers 6,000 years ago and vast quantities of crushed shell fragments have been swept up onto the shoreline by storm after storm. Strong onshore winds have blown this sand inland to the broad, flat spaces beyond the grass-lashed dunes and towards the edges of the peat bogs. Aided by generous rainfall, the calcareous sand has formed thin, alkaline soils and acted as a soil sweetener where it mixed with acidic peats to produce swards of rich grassland.

Natural processes established the machairs, but humans have cultivated them for many generations. Fertilised with seaweed from the shore and dung from grazing livestock, the soil produces good yields of oats, barley, rye and potatoes, and the mix of grasses and herbs makes for excellent pasture. Low-impact agriculture has become a part of the machair ecosystem.

The abundance of a machair is most obvious in spring when it becomes a carpet sewn with buttercups, red clover and vetch, eyebrights, silverweed and ragged robin. A single square metre might contain as many as forty-five plant species.

Unconformity

In the Scottish Borders, beside a lay-by on an unnamed road that leads to a building supplier's depot, is a humble sign informing accidental visitors and pilgrims alike that one of the world's most significant geological sites stands a short distance away. At this site in 1788, James Hutton made an observation that liberated his science from the shackles of religious dogma and changed our view of time.

The accepted wisdom among many of Hutton's contemporaries was that the rocks of the earth had been formed either by God's act of creation, in the case of igneous rocks, or laid down by the receding waters of the Great Flood, in the case of sedimentary rocks. The date of creation itself had been pinpointed by Archbishop James Ussher in 1650. He tallied the generations of begetting in the book of Genesis until he got to Solomon, and then started to piece together a chronology based on other biblical, Roman and Persian sources until the birth of Christ. Using this method, Ussher calculated that the universe began at dusk on Saturday, 22 October 4004 BCE. He would have been more accurate had he been trying to date the creation of betting shops, since 4000 BCE marks the earliest evidence for both accountancy and the domestication of horses.

In contrast to Ussher's, Hutton's theories were based on the evidence of natural history, which suggested that the world was much, much older than 6,000 years. Before he became interested in geology, Hutton had studied classics, been apprenticed to a lawyer, taken a doctorate in medicine and been a partner in a successful chemical-manufacturing plant. When he inherited a lowland farm from his father, he approached agriculture with the same methodical curiosity that he had applied to all his studies, experimenting with land management and animal husbandry to great effect. But Hutton moved from one interest

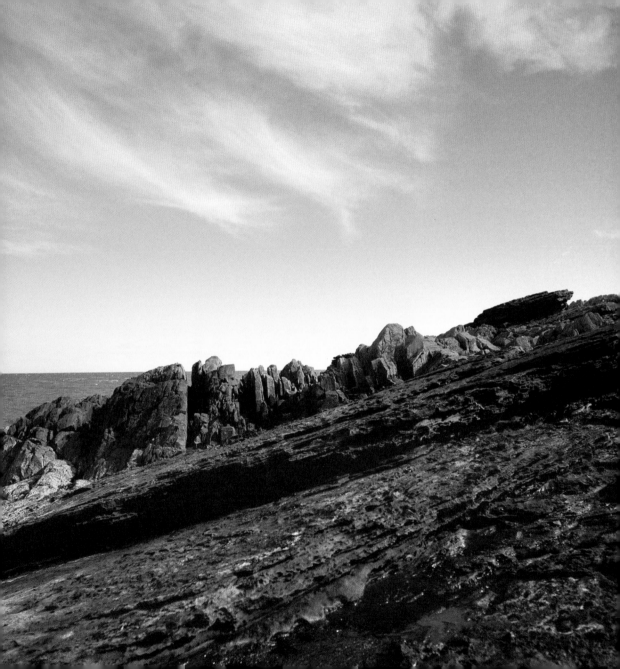

to the next like a man always in search of deeper mysteries to illuminate, a man who embodied like few others the Age of Enlightenment in which he lived. In the new but growing science of geology he finally found a horizon wide enough to capture his whole attention.

It was on the farm that he first turned his great powers of observation and deduction towards stone, water and sediment. Rather than consider granite a 'primordial' rock, Hutton perceived its crystalline form as the product of immense heat and, in a characteristically brilliant leap of imagination, correctly inferred that it had been pushed into place from below while in a molten, fluid state. He also realised that the erosion he saw working on a small scale in rivers could, and would, wash mountains into the sea, given the time to do so. Time was the key to explaining Hutton's observations, but in the conventional account of geology there simply wasn't enough of it. While other geologists saw a simple linear development from creation to the present day, Hutton began to see a cycle of erosion, sedimentation and orogeny (mountain building) that stretched back aeons.

For having, in the natural history of this earth, seen a succession of worlds, we may conclude that there is a system in nature; in like manner as, from seeing revolutions of the planets, it is concluded, that there is a system by which they are intended to continue those revolutions. But if the succession of worlds is established in the system of nature, it is in vain to look for anything higher in the origin of the earth. The result, therefore, of this physical enquiry is, that we find no vestige of a beginning, – no prospect of an end.

(from Hutton's *Theory of the Earth*, 1795)

Knowing that his ideas would face a sceptical reception from the scientific community, Hutton set out to find clear evidence to support them. Above all, he wanted to find a site where two distinct sets of rock strata could be seen at an angular unconformity, thereby proving that more than one period of sedimentation must have occurred, and that the eras were separated by periods of movement and erosion. Hutton's theories were confirmed for the first time in 1787, in a stream bank near Jedbergh, where he found the juxtaposition he had been looking for: vertical strata of sedimentary rock running underneath horizontal strata.

This single observation was encouraging but not conclusive. Tracing the Jedbergh rock beds across the landscape, Hutton predicted that he would find similar formations on the coast, and the following spring he and his friend, the mathematician John Playfair, travelled along the Berwickshire coastline

looking for corroborative evidence. They found it in a dramatic unconformity at a headland called Siccar Point. Hutton's own account of the find is factual and precise, but a little constrained by the need for scientific rigour. Playfair, on the other hand, was less inhibited, and it's his account that captures the full epic significance of the discovery:

On us who saw these phenomena for the first time, the impression made will not easily be forgotten. The palpable evidence presented to us, of one of the most extraordinary and important facts in the natural history of the earth . . . We felt ourselves necessarily carried back to the time when the schistus on which we stood was yet at the bottom of the sea, and when the sandstone before us was only beginning to be deposited, in the shape of sand or mud, from the waters of a superincumbent ocean . . . The mind seemed to grow giddy by looking so far into the abyss of time; and while we listened with earnestness and admiration to the philosopher who was now unfolding to us the order and series of these wonderful events, we became sensible how much farther reason may sometimes go than imagination can venture to follow.

This sudden and extreme change of temporal perspective must have been dizzying indeed: years stretching away and away, like the staircase in *Vertigo*, until we lose our grasp and fall into insignificance.

The precipitous path down the cliff to Siccar Point could easily lead to a less metaphysical, but equally terminal, plunge but for a fixed climbing rope that provides welcome security. Once at the foot of the cliffs it doesn't take long to find the rocks that changed time. The slender line that separates the deep ochres of the sloping, old red sandstone and the concrete-coloured, vertical strata of greywacke represents a period of about eighty million years. Enough time for the older rocks to be raised from the seabed, folded, eroded and then submerged again to become the resting place for new sediments.

Hutton called his new sense of time 'deep time', and while it was clearly incompatible with the biblical accounts of creation, he was less concerned with destabilising the edifice of religion than he was with building the structures of science. His work gave the science of geology a foundation from which it could develop anew, and influenced many later scientists, including Charles Darwin.

While he was certainly not the first person to see unconformities, and probably not the first to be curious about their formation, it was Hutton's own unconformity of mind that allowed him to grasp their significance and allow his reason to lead his imagination into the unknown.

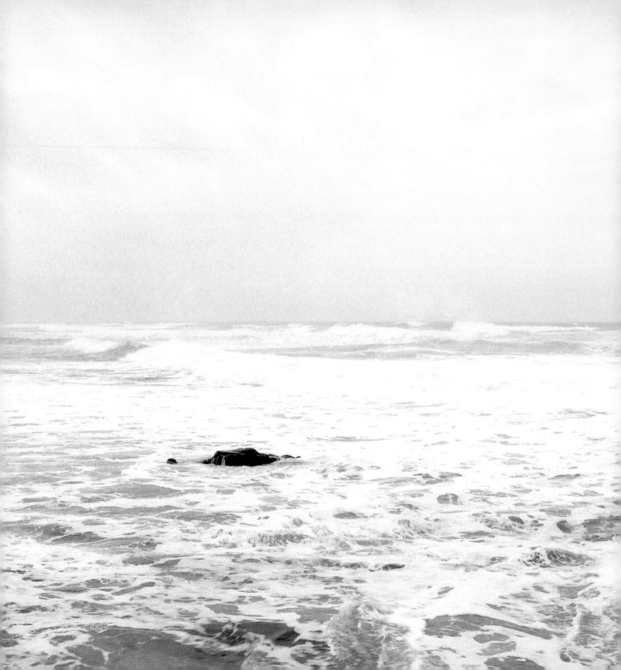

Sgeir

An isolated offshore rock that may be submerged by the high tide is called a 'sgeir' in Scotland and a 'skerry' in England. Both words come from the Old Norse '*sker*', meaning 'a rock in the sea'. Small sgeirs are generally less likely to have names unless they lie in the entrance to a bay or inlet and present a danger to boats.

Sula Sgeir, which lies about forty metres north of Lewis, is one of the most remote fragments of the British Isles and is named after its principal inhabitants, a colony of *súla* (Old Norse for 'gannet'). Written accounts from as early as the sixteenth century describe men from Ness rowing out to Sula Sgeir in small boats without navigational equipment to collect gannet chicks. The chicks were, and in fact still are, dried and eaten as a delicacy called 'guga', the flavour of which is likened to fishy beef or salty goose.

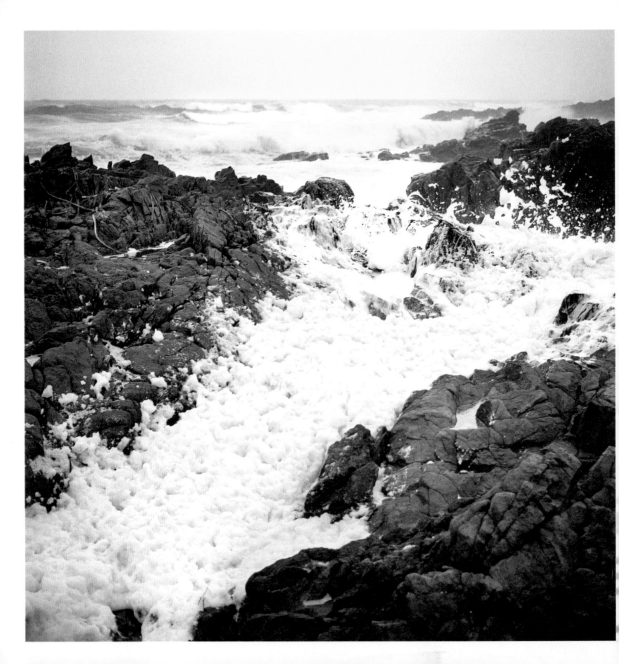

Spume

Spume, or sea-foam, is made by waves that churn seawater with organic compounds from plankton and algae. These compounds act like the surfactants in bubble bath, reducing the surface tension of water to make bubbles easier to produce and more stable. The combination of large quantities of organic material and heavy seas can produce prodigious quantities of spume.

In September 2012, after heavy storms in the North Sea, the Footdee area of Aberdeen was engulfed by spume. Those who complain about the ubiquity of coffee shops might see in the footage of this event the literal manifestation of their worst fears: whole streets were covered in a great quivering tide of beige foam, very much like a monstrous, frothy latte.

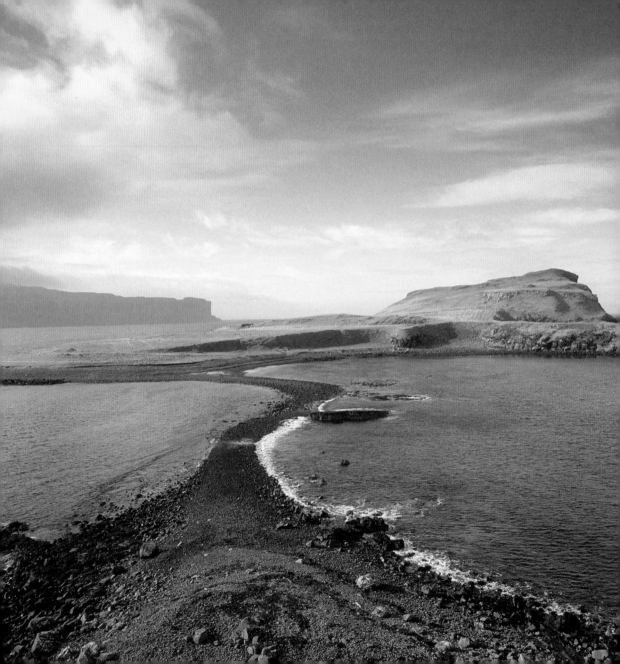

Tombolo

'Oronsay', and the Gaelic '*orasaigh*', are common names for islands around the Scottish coast. The word comes from the Old Norse '*örfirisey*' meaning 'ebb-island' and is used in particular for islands that are connected to the mainland at low tide by a spit – a ridge of sand or gravel deposited by wave action. Any spit that connects an island to the mainland is called a 'tombolo' (Italian for 'mound') and in Scotland a tombolo that is composed of gravel rather than sand is often called an 'ayre' (from '*eyrr*', Old Norse for a shingle beach). A tombolo is also a kind of *isthmus* (from the Ancient Greek '*isthmos*' – 'neck'), which can be any narrow strip of land, with sea on either side, that connects two larger areas of land.

An island connected to the mainland by a tombolo that isn't covered at high tide, or only covered by exceptionally high tides, is called a 'tied island', whereas an island whose tombolo is usually covered at high tide is called a 'tidal island'. Mistaking one for the other could get you stranded, wet – or worse.

Tidewrack

On any given beach, the high-tide line is typically marked by the assortment of natural and man-made remnants – called 'tidewrack' – that are fly-tipped onto the sand by the retreating waves.

The three meanings of 'wrack': 'wreckage', 'marine vegetation' and the archaic 'retributive punishment' encompass, with disquieting precision, much of the wider significance of this strip of detritus. Tidewrack would once have been composed of driftwood, kelp and other marine vegetation, but during the twentieth century the mix came to include more and more plastic, as this most un-biodegradable material became ubiquitous. There is now scarcely a beach in the world that isn't endowed with its own multicoloured display of the many and various uses of polymers. Of these uses I think two deserve special mention:

'Ghost nets' – Commercial fishing nets are now almost exclusively made from nylon and HDPE (high-density polyethylene), which are extremely resistant to damage from saltwater and UV light. While this is good for fishermen, it means that lost or abandoned nets won't degrade and can continue to pose a threat to sea life for hundreds of years. These ghost nets drift with the ocean currents, and by the time they wash up onshore they have often become shrouds for unfortunate seals, turtles, dolphins and whales.

'Nurdles' – Also known as 'mermaid's tears', these small pellets look like fish eggs but are actually an early stage in the life cycle of plastics: an easily-transportable bulk material that is ready to be melted and processed into anything from bottles to fleeces. Sadly, the resemblance to a food source isn't lost on the many species that ingest nurdles with dire and sometimes fatal consequences.

The things we discard, through carelessness, wastefulness and thoughtlessness, return in tidewrack like guilt, and in this sense they fulfil that archaic meaning perfectly.

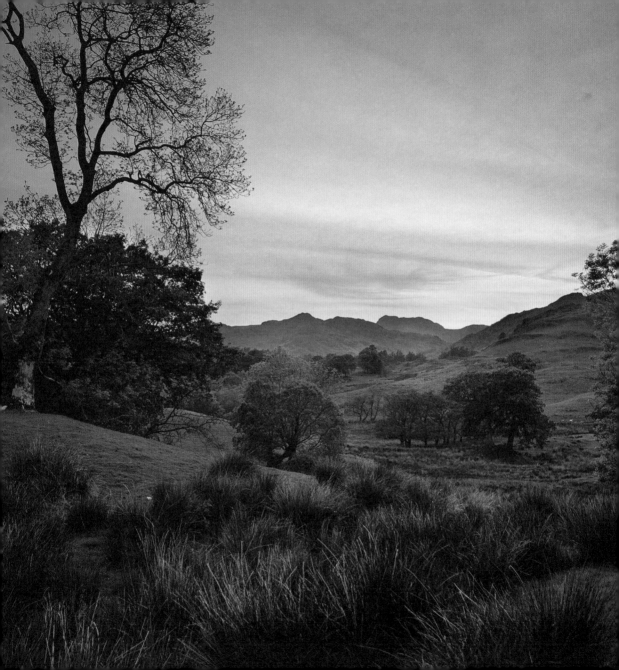

LAKES AND DALES

Among the waiting crowd at the biannual Gaping Gill Winch Meet in North Yorkshire there was something like a sense of pilgrimage. Each of us had travelled there for the same purpose, walking the short nature trail that led north from Clapham village, past the show caves and out onto the moor, where a small, clustered settlement of colourful tents dotted the banks of Fell Beck. Our common goal was not a spiritual ascension but a physical descent into one of the most extraordinary subterranean spaces in Britain.

Of the many potholes that perforate the slopes of Ingleborough Common, at least twenty are entrances to the Gaping Gill system and lead to the chamber itself via dark, tight, sinuous tunnels that have been dissolved out of the rock by the endless percolation of water. The winch, which is in place for just one week in the spring and one week in the autumn, offers a shortcut in and out of the cave, a rare opportunity that attracts thousands of people each year.

A numbered, metal dog tag worn around our necks and a counter by the winch helped us keep track of the queue ahead, and when our turn drew close we were advised to make use of the waterproof overalls provided. Although dams had been constructed to divert the beck that usually runs into the hole, there would still be a fair amount of water falling on us as we descended. Donning the overalls was a sensible precaution, but also felt like a moment of transition, as though we were marking our entrance into holy orders by accepting the habit of this community. If we were the neophytes, then the acolytes were the serious potholers among us, easily identified by their well-fitting boiler suits, high-powered head torches and neat-looking kitbags. Their capable nonchalance suggested a deeper level of understanding and hinted at secret knowledge.

I started to remember a radio feature I'd once heard about locations thought to be the real entrances to mythological underworlds. For the Greeks, the caves at Cape Matapan on the southern mainland peninsula were the actual portals through which Orpheus had descended in search of Eurydice and out of which Hercules had dragged Cerberus with his triptych of snarling, slobbering heads. The drool that fell from Cerberus'

maws was said to have turned the plants it watered into wolfsbane, a piece of folklore that illuminates the fact that this plant's roots render a deadly poison. Myth and folklore add layers of meaning to landscapes, and in return the landscape grounds the stories in reality.

When at last I sat in the chair and was lowered into the hole, I was still half-thinking about the underworld and the wisdom of descending into it. The circle of daylight receded above me, scattering into a haze through the falling waters of the beck, and as my eyes adjusted I began to see the walls of the cavern moving past and then opening out into an unfathomable space. The drop from the surface is a little more than the internal height of St Paul's, and took less than a minute at a swift pace. Once I'd reached the bottom I was helped out of the chair, and someone stepped forward to take my place for the ride back up. Behind them was a long but orderly queue of people waiting to do the same. In this subterranean context their cheerful patience seemed to challenge Sartre's observation about hell and other people.

I set to work making photographs as best I could, finding corners where I could fit the expanse of the cavern into the frame and avoid the worst of the drips and deluges. With light levels dropping below the working limits of my meter, the exposures were long and mostly estimated. My fellow pilgrims wandered around with torches while the serious potholers disappeared into nooks and crannies in the far corners, like mice into the skirting. After an hour or so I packed up and joined the end of the queue by the chair, falling into conversation with the man next to me with the ease that sometimes comes with a shared experience. We agreed that it was wonderful to be able to experience this incredible space. 'Like a cathedral,' I offered. 'No, I don't think so,' he replied. 'Man could never make something as amazing as this.' We both gazed about in mute appreciation and I wondered whether this was the quality that had drawn so many: had we all been looking for a glimpse of something beyond humanity, a monument to what we cannot do?

One evening, a few days later, as the sky blushed and the land dimmed to shadows, I stood at a gate near Coniston and watched over a pastoral scene that was both timeless and quintessentially modern. On a hillock in the middle distance a man bestride a quad bike was talking on his mobile phone while two sheepdogs, alert as bodyguards, stood sentinel. Every now and then shiftless breaths of wind delivered snatches of his conversation. On impulse I looked at my own phone, which had only occasionally

found a signal here in the byways of the Lake District. It was still showing 'no service'. The man on the hill finished his call and, flanked by his outriders, drove off.

Had he specifically chosen that hill, I wondered. Perhaps it was one of those rare points in this landscape where a mobile signal converged with enough strength to make a call. Just as fisherman share knowledge of the shifting tides and currents, now locals share tips on how to find hotspots contingent on wind strength and direction. In hilly, rural areas where the signals seem to turn and scatter just like startled minnows, this knowledge is invaluable, one of the latest of many layers of information to settle onto the landscape.

I would like to think that these new layers will settle alongside older ones, like those of myth and folklore, without obscuring them. Knowing that Cerberus' drool created the poisonous wolfsbane is perhaps not as immediately useful as knowing where you can get reception, but it certainly enriches life more than any cold caller.

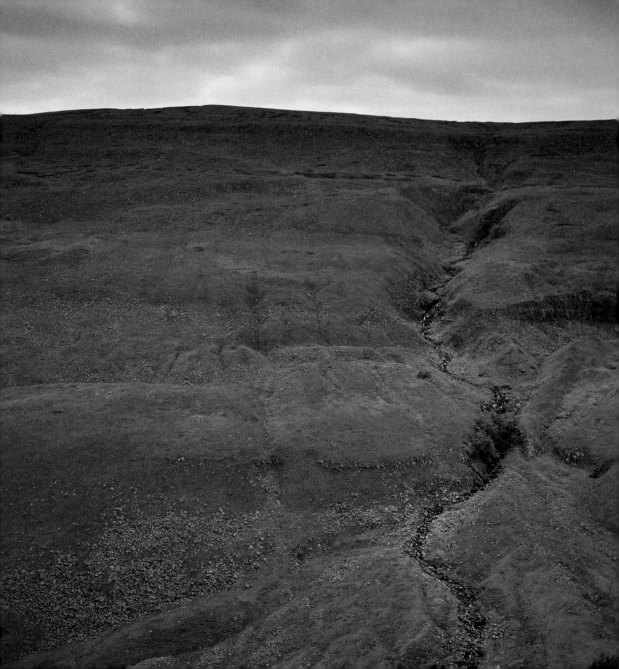

Beck and Gill

Maps will not help you to distinguish between these two words, used interchangeably to denote fast-running streams in steep terrain. Their original uses, though, convey a useful distinction. The word 'beck' is of Old Norse origin and is cognate with the German word '*bach*' meaning 'brook' or 'stream'. 'Gill', derived from the Old Norse '*gil*', was originally a word for a cleft or ravine. Since the roots of both words stem from the same lexicon it's likely that their meanings have become closer over time, through use, misuse and association. I think there is some utility in at least being able to say that a beck flows in a gill but a gill doesn't flow in a beck, or that a dry gill is still a gill but a dry beck is gone.

The alternative spelling 'ghyll' seems to have appeared first in Wordsworth's 1793 poem 'An Evening Walk', which contains these lines:

Then, while I wandered where the huddling rill
Brightens with water-breaks the hollow ghyll
As by enchantment, an obscure retreat
Opened at once, and stayed my devious feet.

A 'rill' is yet another word for a stream, but usually one smaller than a beck, perhaps even one which has a fleeting existence and is without a permanent course. Wordsworth's rather affected spelling caught on, and its erroneous appearance of old-world authenticity might account for its preferential use by hotels and tourist attractions.

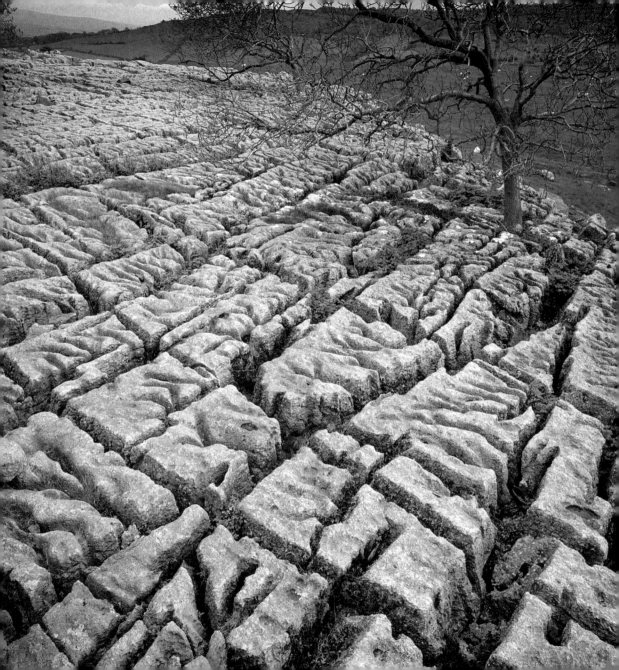

Clint and Gryke

Limestone pavements appear barren at first sight, but they can be deceptively rich environments. Once you start to look down into the grykes (the gaps) you find all sorts of life. Several rare species like pale St John's wort, baneberry and juniper thrive in the shaded, humid conditions between the clints (the flagstones) where they can evade grazing animals and can shelter from strong winds.

These landscape features began forming around 12,000 years ago, when the glaciers retreated to expose horizontal beds of limestone from which they had scoured away layers of topsoil. Limestone is soluble in rainwater, even more so in acid rainwater, and so the existing faults and cracks were slowly dissolved and enlarged. Clints and grykes that formed under a thin remnant layer of soil are more rounded than those that were fully exposed, and the additional acidification from the breakdown in organic matter in the soil can accelerate the process. Eventually, the topsoil is itself washed down into the grykes, where it provides a purchase for the range of flora and fauna that can exploit this niche habitat. Shrubs and small trees often grow to fill the grykes, which in spring become grouted with green leaves.

Both words are northern English dialect but they may also share a Scandinavian etymology: '*klint*' means 'cliff' in Danish and 'hill' in Swedish. '*Kriki'* in Old Norse meant 'crack' or 'crevice'. Those in need of a greater range of terms for erosion features in water-soluble rocks might look to Germany: *flachkarren* are clints, *kluftkarren* are grykes, *rundkarren* are rounded runnels, *kamenitzas* are hollows, *rillenkarren* are sharp-ridged grooves, *rinnenkarren* are wider, deeper grooves, and *trittkarren* are small, heelprint-shaped terraces.

101

Fell

From the Old Norse *'fjell'* ('mountain'), 'fell' has endured in the north of England as a word for the hilly uplands: areas of rough, common grazing on the moors.

Cross Fell, rising on the eastern flank of the Eden Valley, is home to the Helm Wind, the only named wind in the UK. This north-easterly roars down the hillside into the valley, forming a cap of cloud above the ridge and a rolling bar of cloud beyond it to the west. The Helm Wind can blow for days, rather like the Mistral in France or the Santa Ana in Southern California and, like both these winds, its persistence and force has been blamed for headaches and depression among local residents.

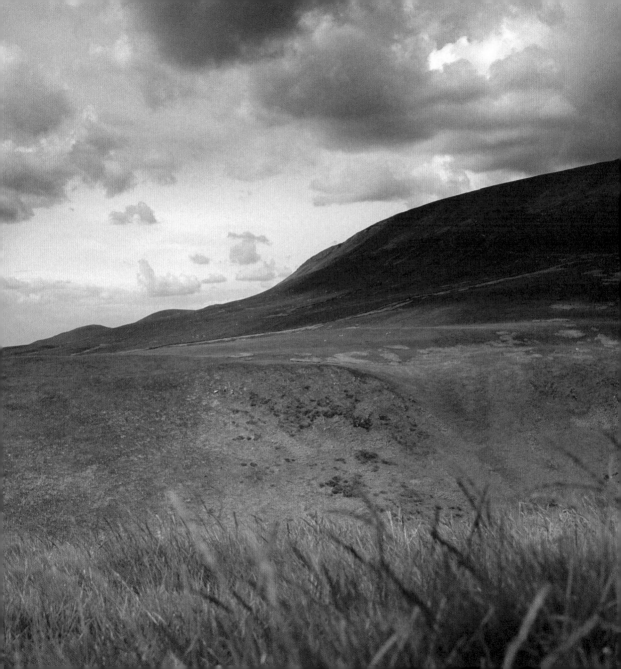

Scar, Scarp and Escarpment

The relationship between these terms can be confusing, especially as there are similarities between the landforms they name: a scarp might itself feature several scars.

In spite of appearances, 'scar' has no common etymology with the other two words. It derives from the Old Norse '*sker*' ('crag') [*see also* SGEIR], while 'escarpment' and 'scarp' both came from the Italian '*scarpa*' when it had two meanings: 'slope' and 'shoe'. From what I can tell, 'scarp' came directly into the English vocabulary while 'escarpment' picked up its accoutrements en route from France. For all that, these two words are now practically synonymous.

An escarpment is a ridgeline with a saw-tooth profile. The steep side (the scarp face) is cut through the strata while the other side (the dip slope) follows them in a gentle incline. The North and South Downs are both escarpments, as are many landforms that are locally named 'edges', such as Wenlock Edge and Lincoln Edge.

Scars are smaller, less extensive landforms that are dominated by a single outcrop of rock rather than involving multiple layers of strata. As cliffs, like White Scar (*pictured*), they might resemble an escarpment in miniature, but they can also be rocky hilltops like Nab Scar or gorges like Gordale Scar.

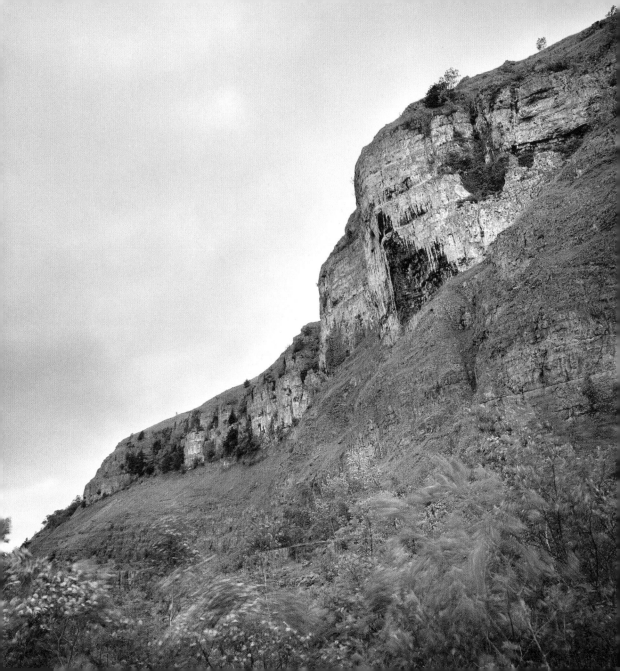

Moss

Not as in the plants, but as in the landscape feature that they create – 'moss' is a fairly common word in the north of England for a boggy wetland. In Cumbria it's used for lowland raised bogs in particular. These form in poorly drained dips in the landscape, where the collected water provides ideal conditions for sphagnum moss. Localised in the dips, the gradual build-up of peat (*see* MIRE) forms a dome that can rise up to three metres above the surrounding land. There is something counter-intuitive about the ground becoming wetter uphill but this is often the case with mosses that are surrounded by well-drained fields. As you enter the edges of the peat dome you are essentially walking onto a massive sponge holding water that has nowhere to go.

Raised mosses are mosaic landscapes of heath, pasture, willow or alder carrs (*see* CARR) and drier woodland of scrubby birch or Scots pine. This diversity of habitat supports a huge range of wildlife, giving mosses an ecological significance disproportionate to their size.

Outside Cumbria, 'moss' usually refers to upland blanket bogs, which are large, open heathlands with extensive peat layers of more uniform thickness.

Nurse Log

Saplings that grow on the remains of another tree gain a few key advantages: being raised up off the ground, they avoid some of the attentions of browsing herbivores and are less shaded by undergrowth. Unlike those seeds that germinate on the woodland floor, they have no need to compete with ground-level vegetation. In fact, in the temperate rainforests of the west coast of Canada and the USA, where this term originated, fallen trees often become nurseries for seedlings that grow along the length of decaying trunk like a memorial avenue.

The growth of trees on nurse logs and stumps is only hampered by their eventual need to put their own roots directly into the ground, a task that requires them to grow around their host. Once this has been accomplished, the trees can continue to develop normally. As the nurse log further decays, it sometimes leaves a gap underneath the living tree, which then resembles the arm of someone doing push-ups on their fingertips.

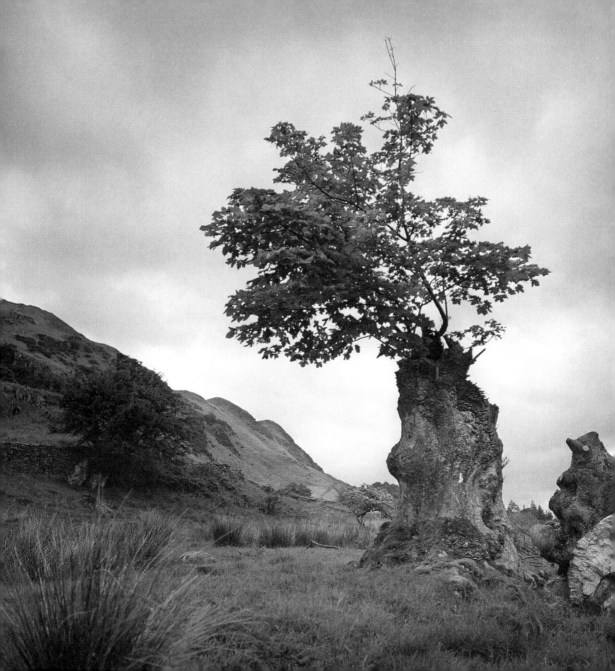

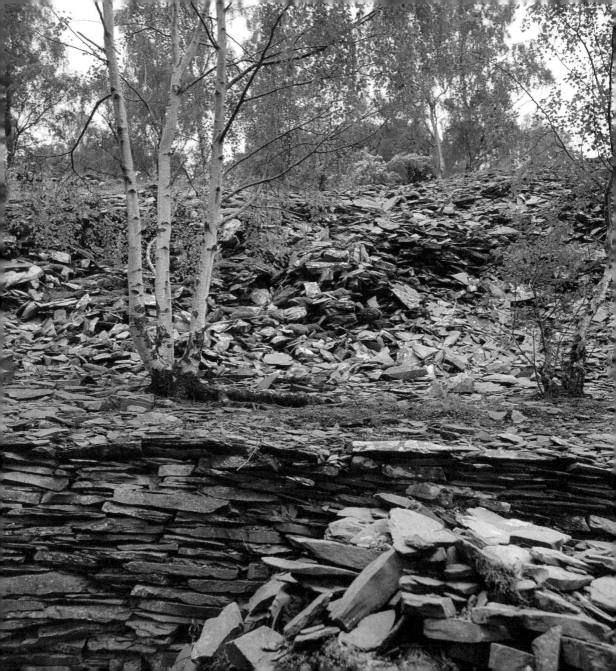

Shivver

These are the sharp fragments of slate that accumulate naturally under slate cliffs or as a product of quarrying. This is a Cumbrian dialect spelling of 'shiver', which has had the meaning 'fragment' or 'chip' since the middle ages and derives from the Germanic 'scivero' ('splinter') from which, in a nice little etymological loop, derives the modern German word for slate: 'schiefer'. This meaning has almost disappeared from use, but it persists in the cod-nautical expression 'shiver me timbers', which refers to splintering rather than quaking.

All scree slopes, strewn with loose rock fragments, are difficult to walk on, but shivver is probably the worst of them. Slate is sharp and smooth-faced, so easily displaced. At any moment you may find yourself sliding towards something resembling a julienne cutter on an ankle-slicing scale. The tumble of shards that a misstep unleashes chimes like broken porcelain and moves like a tremor, or a shiver, down the slope.

GINNY GREENTEETH
/ˈdʒɛnɪ griːn.tiːð/

RELATED TERMS: loch,
lochan, will-o'-the-wisp

Ginny Greenteeth

In modern-day Japan, signs warning of the dangers of deep water often feature a strange, beaked creature – half-child half-reptile – dragging victims to their death. This creature, called the *kappa*, has been a part of cautionary Japanese folk tales for centuries. Similar creatures are present in many other cultures: the *rusalki* of Slavic folklore are river mermaids who were thought to be most active during the week-long fertility festival called Green Week, a time when all swimming was strictly forbidden; the Australian-Aboriginal *bunyip* is a waterhole-lurking predator described so variously in accounts that it might have all shapes and none; the Scottish kelpie restricts its shape-changing to horses and humans but is no less dangerous to the unwary. The *nixie* dwelt in German rivers and inspired Wagner's Rhinemaidens, and in Norway the *nøkken* played their own sweet music on (presumably waterproofed) violins to lure victims.

That these myths should be so widespread and yet so similar suggests to me that they all served a purpose – the same one the *kappa* still serves – to make people, especially children, respect the dangers of water.

Ginny Greenteeth is just one of many English water spirits available for duty as frighteners. Her colleagues include Peg Powler, resident in the River Tees, and Grindelow, who is more peripatetic, covering Yorkshire and Lancashire. Ginny – or Jenny, or Jeannie – is described as green-skinned, with long, rank hair and sharp teeth, her modus operandi is the classic lure-and-drown and, uniquely among water spirits, her name is also used to describe places, thus a ginny greenteeth is a weed-covered pond, or a moss- and algae-covered stream.

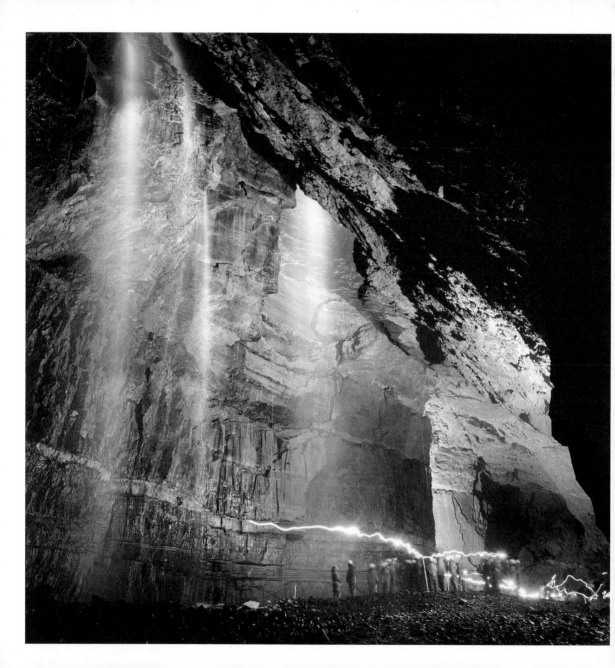

Pot

The moors of North Yorkshire are punctured by holes big enough and deep enough to be given a wide berth by walkers and to incite gleeful investigation by cavers. These potholes are the entrances to vast networks of underground chambers and passages, dissolved out of the limestone by the relentless flow of water. Though 'pothole' and 'pot' are more or less interchangeable terms, the former is used more for the opening and the latter for the space beneath. A pot is therefore a subterranean chamber that has an opening in its roof. It's very tempting, given the similarities in form, to assume that this use of 'pot' has derived from the more common meaning of 'a vessel' but evidence suggests unrelated, if obscure, origins.

In contrast to caves that lead more or less horizontally into the underground, pots, which often open onto sheer drops, require a more technical approach. This 'vertical caving' relies extensively on adapted climbing techniques, and it was through experimentation by the sport's early practitioners that the first mechanical rope ascenders were developed.

Exploration of the British subterranean landscape expanded rapidly in the mid-twentieth century as the sport of potholing grew and new cave systems were found. Perhaps because of this concentrated period of discovery there is a certain footloose functionality in the names of underground places, which range from the emotive to the eponymous to the flat-out prosaic. Disappointment Pot, Corky's Pot and Stream Passage Pot are all connected to Gaping Gill, which is itself a pot in all but name.

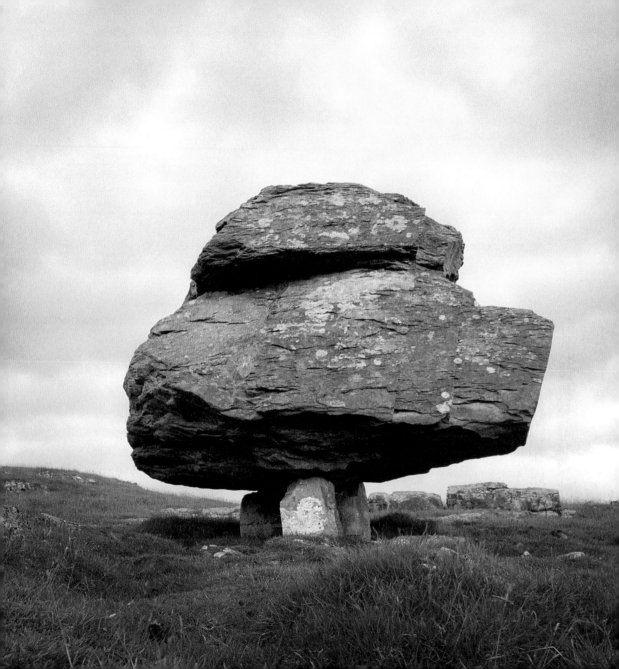

Erratic

These are large rocks that have ended up far from home. Carried by glaciers that then melted, they are left, incongruous and obvious as beached whales, waiting for a tide that may never come back in. This can happen to individual rocks or to a whole group, as with the Norber erratics near Austwick in Yorkshire, a whole pod of beached Silurian greywacke boulders stranded on a Carboniferous limestone pavement. A gap of around one hundred million years separates the older erratics from the younger pavement, and though age is hard to discern in rocks, the two are helpfully colour-coded by lichens: those that grow on the greywacke are yellowy-green, whereas the species on the limestone is white.

The presence of massive blocks of stone that were clearly nothing to do with the surrounding rocks conjured some imaginative local legends. It was claimed that if the solitary twenty-ton erratic boulder in the village of Merton in Norfolk was ever removed from its resting place, flood waters would rise and inundate the area, and possibly the world. Despite this threat, the feat has been attempted at least twice, according to reports: the first attempt was made in the mid-nineteenth century using manpower fuelled by beer and ended in an erotic debauch, the second attempt set a steam thresher to the task, but ended less joyfully when a rope snapped and killed a man. The Blaxhall Stone is a five-ton erratic that in the last ice age made its way from the Lincolnshire area to stand like Gulliver among the Lilliputian rocks of Suffolk, but the local legend associated with this rock is that it simply grew in place, having been ploughed up in the 1800s as a stone the size of 'two fists'.

Dub

Before sheep dips there were dubs. When the time came for shearing, sheep would be brought off the moor to a convenient pool in a river where they could be washed and rinsed in preparation. It's quite common to find the remains of old stone sheepfolds near river pools, though nowadays dubs are more likely to be used by hot walkers for recreational dipping on sunny days.

Dubs are found throughout Cumbria, but the word's precise meaning varies depending on location. In central Cumbria a dub can be a stretch of still waters running deep or just a pond. In the south-west of the county, and in parts of Scotland, a dub might be little more than a puddle of rainwater on the road, which in terms of bathing is strictly for the birds.

Doake

Flatfish hunt by ambush, making use of their shape and camouflage to lurk inconspicuously just beneath the surface of the sand or silt and await unwary passers-by. While they are in this state of concealment, however, some are themselves preyed upon by an unusual form of fishing. Flounder tramping involves wading barefoot in the shallows of the rising tide to seek out buried fish with your feet. Sensitive toes are useful, but success entirely depends on being able to replace the strong urge to lift your foot when something squirms beneath it with a reflex to press down and secure your catch. This kind of fishing has been practised in Scotland and the north of England for centuries, and for several years the small village of Palnackie in Dumfries and Galloway was the venue for the annual world championships.

In Cumbria, a doake is the shallow platter-shaped indentation that remains when a flounder, or similar, has left its lurking place to pursue food or to escape capture. Since the fish are practically invisible once they have shuffled themselves into place, doakes can be the only indication to would-be trampers that there are, or have been, fish nearby.

The term 'ass groove' for the indentation left by habitual occupation of one spot on the sofa was coined by Homer Simpson. 'Doake' seems to me to be an ideal alternative term, perhaps for use in the presence of genteel relatives.

Epilimnion

When you're swimming in a deep lake and you feel that your feet are dangling in much colder water, it can suddenly make imagined dangers palpable and cause an irreversible drop in morale (*see* LOCH AND LOCHAN). Instinctively, you retract your feet from the cold, and without a steely grip on your nerves this withdrawl can very easily become a full retreat, with you tearing back to shore, pursued by all your irrational fears.

Perhaps this just happens to me. In any case, this experience illustrates the thermal stratification of lakes that happens typically in summer and winter, when distinct zones of temperature form at different depths.

Changes in the relative density of water and the ambient temperature account for this layering. Water is at its densest at 4°C, and so a layer at this temperature is often at the bottom of a lake. In the winter, the layers above become progressively colder as you ascend, with ice, which is less dense than liquid water, forming on the surface. In summer, the arrangement is reversed, with the warmest water at the surface and the temperature dropping as you go deeper. This warm layer is the epilimnion. Spring and autumn are periods of transition between these two different states of layering, during which the waters are thoroughly mixed up, which helps redistribute oxygen and nutrients throughout the lake.

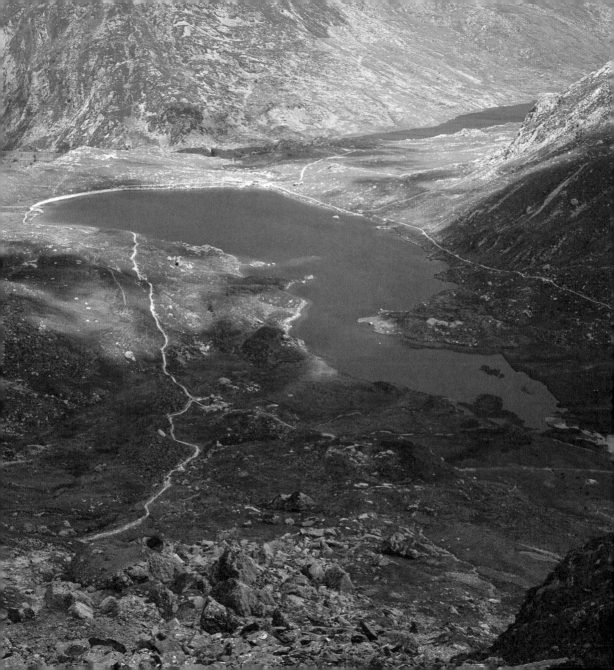

WALES

In his office at the Ogwen Warden Centre, Guto Roberts unfolded a large-scale map and began to sing. It wasn't a rendition of 'How Green Is My Valley' (though there were similarities), it was a hymn of place, colour and form, each lyric a toponym set to the music of the Welsh language. 'Carnedd y Filiast ... Mynydd Perfedd ... Bwlch y Brecan ... Foel-goch ... Creigiau Gleision', words that describe a journey step by step: cairn like a greyhound, mountain in the middle like intestines, through the gap to the bare red summit next to the yellow crags. 'You often find these contrasting colours next to one another,' Guto explained as he translated. 'It helps to differentiate between similar features – there are two Foel-gochs ['bare red summits'] one is next to the yellow rocks, the other is next to Clogwyn Du, the black cliff.'

Part of Guto's job involves managing the national nature reserve in the area, a role which takes him onto the hills year-round, monitoring species and tracking changes in the ecosystem. This work would account for his familiarity with the landscape, but I get the impression, from the fluency of his descriptions, that a lot of his knowledge, or at least

his sense of the land, was absorbed in childhood. I think there's an effortlessness to the things we learn as children that makes it easier for us to share them. It's not that we don't value them, just that we've paid them off so long ago that we can give them away without counting the cost and expecting anything back.

As Guto guided me across the map I began to appreciate the descriptiveness of Welsh landscape language, and how well-suited it was to communication about places and routes. The fact that the bulk of the Welsh lexis predates mapping goes some way to explain this descriptiveness, since journeys must have been shared in telling, rather than drawing, for centuries. This navigation by narrative is also the way of the Australian-Aboriginal songline, a form of mental mapping that draws time, myth and place into a single line, which can be followed as precisely as GPS. Listening to Guto recite and translate the names I was struck by the similarity with songlines, and not just because of the lyrical quality of the words. Looking again at the map in front of us I realised that even without the contour lines, the icons and

the colour coding, the names hold the landscape. The same could be said for Gaelic and Cornish, but in Wales the link between language and the experience of being in the landscape seems particularly close – knowledge of one vastly enhances the other.

Each time I asked about names on the map, and tried in vain to pronounce them, I felt needles of anxiety. Not so much from the embarrassment of getting it wrong, it was more like the fear of causing harm to a precious thing. In comparison to Guto I seemed to be playing a Stradivarius with a hacksaw. The noises I made were so ugly it was hard not to feel that some actual damage was being done. 'At least you're trying,' said Guto in consolation, perhaps for both of us.

My inept pronunciation is fortunately no real threat to the Welsh language, which suffers more from not being spoken than it does from being spoken badly. The proportion of Welsh-speakers in Wales has dropped slightly in recent years, down to twenty-one per cent in 2011. This isn't a massive reduction, but the fall has been more marked in areas which have traditionally been strongholds, to the north and the west. Given that the Welsh language is so dominant in place names, the prospect of a population with little or no grasp of the language that annotates their landscape is deeply saddening.

This, of course, is the situation in most of the rest of Britain, where so often the descriptive role of toponyms has effectively been commuted to one of simple designation. And if the function of the name is just to label rather than to describe, and place in context, then it becomes that much easier to label it as mine or yours. 'The knoll of the red rocks' becomes 'Tyler's Hill', and simultaneously two fences are erected: one around the hill and one around the language.

I left Guto with a list of landforms and phenomena for which I was hoping to find Welsh terms. He said he would pass them on to others, older people he knew who would recall words that he, a young man (though Welsh-speaking) might not have learnt. Then I set off towards Llyn ('lake') Idwal to head up the steep slope at the back of the cwm ('valley', *see* COIRE) through the Twll Ddu ('Black Hole') and up to the rocky peaks of Glyder Fawr and Glyder Fach, collectively called the 'Glyderau'. I stopped for a moment at the fine gravel beach on the northern edge of the llyn. I'd been here before, with my wife and my daughter when she was just a year old. As with Cornwall and Scotland, I was going over old footsteps without really meaning to. There was a comfort in revisiting familiar places, though I now found myself seeing them differently, more analytically, perhaps because of the nature of this project. Whereas before I

simply appreciated a view, now I was dissecting it and labelling it. Far from deadening the experience, this new level of engagement added something. Physicist and polymath Richard Feynman made the following comment about the idea that scientific analysis somehow takes something away from the appreciation of beauty in nature: 'It [science] only adds to the excitement, mystery and awe . . . It only adds. I don't understand how it subtracts.'

Once above the llyn, looking down from the path to the ridge, I could see out towards the north coast. In the middle distance, downstream from Llyn Ogwen on the Afon ('River') Ogwen sat Bethesda, between hills, and beyond, Bangor and the Traeth Lavan (Lavan Sands). Out there the sun was shining on a blue sea and yellow sands but the Glyderau were in shadow beneath a swirling cloud that seemed to have got snagged on the jagged peaks. Occasionally, holes opened in the cloud where it was torn from its moorings, and through these rips fell shafts of light that scattered off the sharp edges of the splintered rocks. The rocks themselves appeared caught in a perpetual spasm, stuck to the hillside like iron filings around a powerful magnet.

Between Glyder Fawr and Glyder Fach I edged to the lip of the ridge to look down into Cwm Idwal, suddenly finding myself in an upwards blast of wind. Just a few steps from the edge, the wind died back to a whisper. It seemed the gale was racing up the headwall and then continuing its vertical trajectory straight into the sky, leaving the ridge relatively calm. As I looked down again into the valley, the moving air suddenly became visible, clouds condensing as they rose, and in seconds the view disappeared. Vague white shapes whipped past, creating a strong but not unpleasant sensation of falling. What is this called in Welsh, I wondered, do these clouds or does this experience even have a name?

I found a flat stone among the anarchy of rocks on Glyder Fach and studied the 1:25,000 Ordnance Survey map Guto had lent me. There was a route I had planned to take down the northern slope but although I was nearby I was having trouble finding it. The map presented an accurate representation of the topography but not an accurate representation of the experience of that topography. Looking around I started to see features that could be used as waypoints: a stone like a rook's beak, a patch of grass like a picnic blanket, a rock pile like a beacon, but these were like characters without a story, the narrative of how I should move from one to the next was missing. I realised that I didn't need a map, I needed a song.

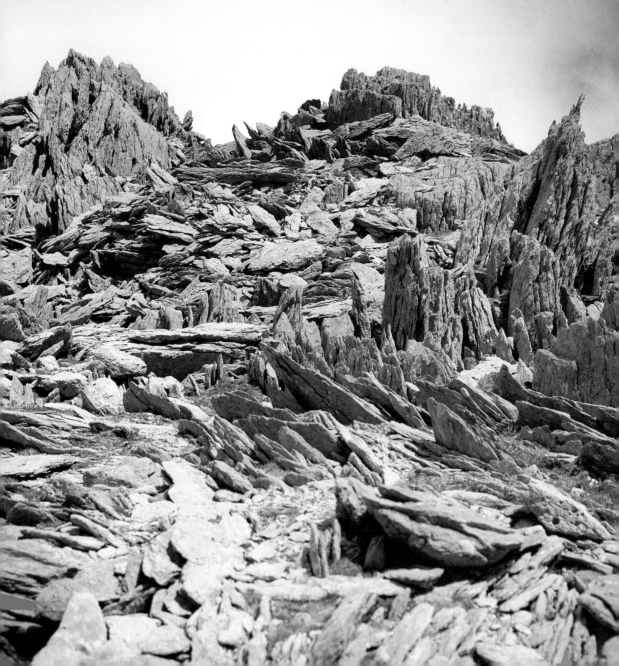

Glyder

The Glyder Fach and the Glyder Fawr are two rock-strewn peaks that rise to the south of Cwm Idwal in Snowdonia. The peaks and the ridge that connects them are a fine example of a blockfield, a spread of angular boulders that have been fractured and shattered by frost action. The German word for this, '*Felsenmeer*' (literally 'sea of rocks'), is often used in geology. In these terms the Glyders, or *Glyderau* in Welsh, would be an angry sea: there's certainly nothing pacific about this landscape. In fact, it's more like a sea of washing-up, with its sharp, jutting edges and awkwardly balanced plates – the kind of sinkful that has you contemplating coffee in a milk jug.

'Glyder' doesn't mean anything – the name is only applied to these two peaks – but there's a consensus that it's derived from the Welsh '*cludair*' meaning 'heap' or 'pile'. In this case, Glyder Fach means 'small heap' and Glyder Fawr means 'large heap'.

There are similarities between Welsh and Cornish: both have their roots in early Celtic languages, and I think it's likely that '*cludair*' is cognate with 'clitter' and 'clatter'. The meanings are similar, and when spoken the three words are very close.

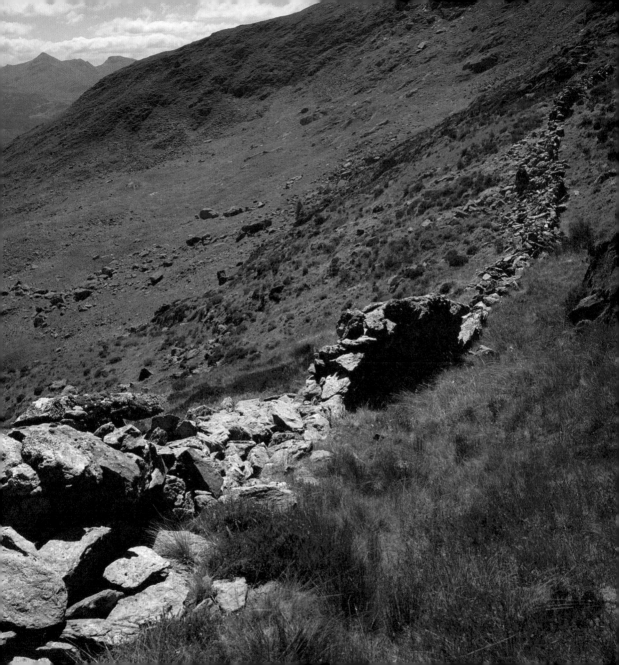

Ffridd

Between the lush lowland grazing in the valleys and the rough, rocky uplands is the ffridd. On a walk up into the hills you enter the ffridd zone as you pass beyond the fences enclosing the pastures, and you stay in it until you clamber over the dry stone walls that originally kept the sheep off the summits. Many of these walls are now ruined and fallen, and the ffridd's boundaries aren't maintained as they once were.

These boundaries date back to the enclosures of the sixteenth and seventeenth centuries, when vast areas of common land were taken into private ownership, a process variously described as the catalyst of the agricultural revolution and class robbery. When limits were imposed on the number of sheep allowed to access common land, farmers were obliged to repair the upper boundary walls, but in recent years the prescribed number of sheep in the ffridd has dropped to match that of the common land, and so there's little incentive to separate the two.

Though they may be free to wander as they please, the flocks tend to stick to habitual pastures, bound by what's called 'cynefin'. This term has no direct translation into English, but its closest equivalent is the word 'heft' (from the German 'heften' for 'to fix or fasten') meaning 'to habituate sheep to a particular area of grazing' or 'an unenclosed area to which sheep have become accustomed'. These ideas hint at something like 'co-fettering' the way that the sheep are as bound to the land as it is to them.

SPHAEROBLAST
/'sfɪərəʊblɑːst/
RELATED TERMS: gall, burr
OS: SH 566 476

Sphaeroblast

A more common name for this growth anomaly in trees is 'burr', as in burr walnut, the curly-grained timber much beloved by luxury-car manufacturers and pipe makers.

For me, this association with driving gloves and sweet tobacco smoke gives the word 'burr' a slightly fusty taint, whereas 'sphaeroblast' sounds like the special attack of a character in a Japanese computer game.

Small sphaeroblasts are quite common on beech trees, where they look like outy belly buttons on the trunk. On other species they occur less frequently, but most hardwoods (including oak, as in this image) produce them from time to time when their buds continue to grow woody material without extending. All sphaeroblasts share the chaotic fractal grain that makes them attractive to wood carvers and wood turners, but those on walnut trees can grow particularly large, hence their use in making furniture and dashboards.

Noah's Woods

Wherever docks have been gouged from estuarial mud, or storms have swept away sand from a foreshore, it's not uncommon to find the remains of ancient forests: tree stumps standing in situ above layers of peaty soil, beech masts and other fragments. These remains are not the result of landslips or material transported by rivers; they indicate the sites of woodland that at some point was inundated by rising sea levels. This distinction was clear to those on the east coast of England who gave these places the name 'Noah's woods' in reference to the biblical flood that they presumably held responsible for the phenomena.

In Wales, submerged forests provided supporting evidence for another legend, that of the Cantre'r Gwaelod, a lost kingdom that was said to have been located between the horns of Cardigan Bay and protected from the encroaching sea by huge dykes (*see* SARN).

Beyond mythology, the significance of submerged forests was overlooked until well into the twentieth century, when the geologist Clement Reid published the first scientific work on the subject. Reid himself accounted for this oversight on the part of his colleagues in his introduction:

> *They [submerged forests] are particularly dirty to handle or walk upon; so that the archaeologist is inclined to say that they belong to the province of geology, and the geologist remarks that they are too modern to be worth his attention; and both pass on.*

Reid's work on submerged forests concluded that they provided clear evidence for sea-level rises, and suggested there had once been a land bridge between England and the European mainland, a hypothesis that has since been proven.

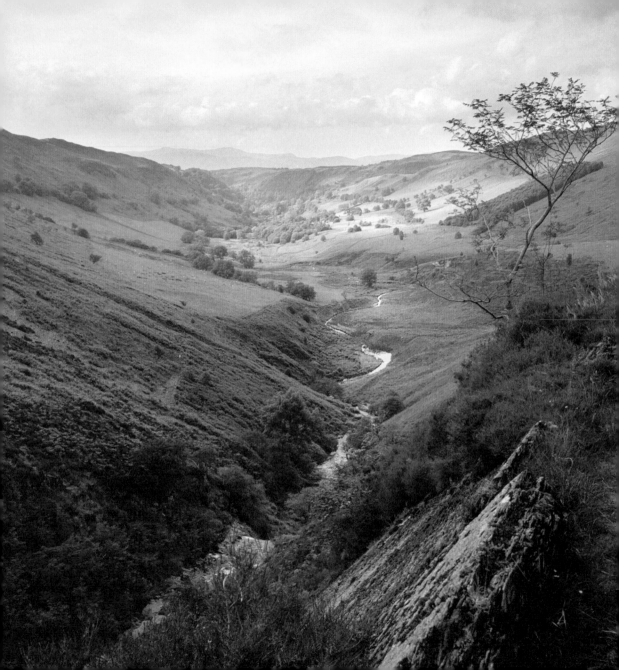

Misfit Stream

This is a watercourse that is too small or too big to have been the shaping force of the valleys it flows through. Oversized or overfit streams are relatively rare, and usually result from a sudden and prolonged increase in glacial meltwaters flowing through valleys eroded by smaller rivers. Underfit streams are common features in post-glacial landscapes, where rivers narrow enough to step across run along the bottom of u-shaped valleys of epic proportions.

The word 'misfit' seems itself incongruous in this context, since water is malleable to any given space, but of course it's into our ideas of the landscape, and in particular its origins, that these streams don't fit. For the term to make sense you have to already have a concept of how the valley was made so that the discordance presents itself.

Gwisgo'i Gap

In Wales a mountain top is said to be *gwisgo'i gap* ('wearing its cap') when it's covered by a cloud. Such clouds are formed when moisture in warm, humid air is cooled and condenses as it rises over high ground. The air warms as it passes over the peak and down the other side, and the water droplets evaporate so that the cloud appears to hover motionless while it is continually renewed and dissipated. It was this phenomenon that I'd seen at the top of the Glyder Fach (*see* this section's introduction), though at the time I didn't know the term. I can now say that I must have been standing just at the brim of the cap, right where the water vapour suddenly condenses as it ascends.

There are many local sayings that associate a capped mountain with the impending bad weather, an association born out of the relatively high humidity necessary for the clouds to form.

A similar formation called a 'banner cloud' occurs at high altitudes, when the trailing edge of the cloud is torn away from the peak by high winds and billows like a flag.

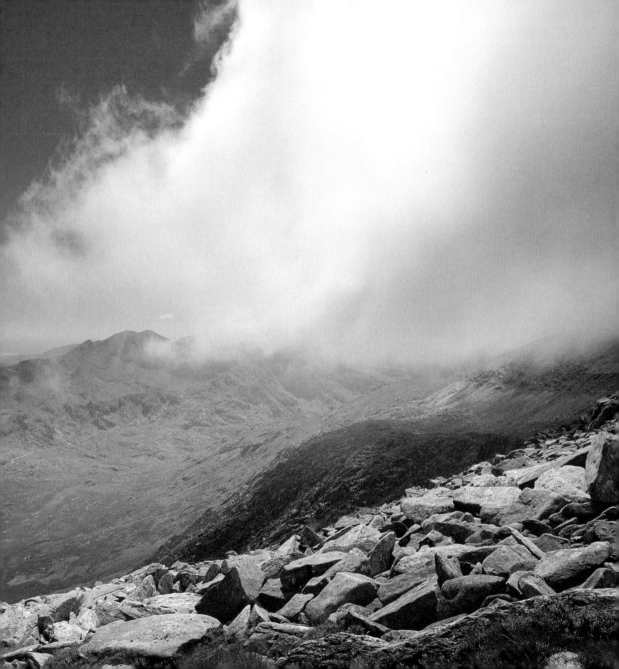

Sarn

This is the Welsh word for a causeway, and its plural '*sarnau*' is the name given to the group of shingle reefs that extend in parallel out into Cardigan Bay. The Sarnau were once thought to be the remains of the dykes that protected the lost kingdom of Cantre'r Gwaelod. Depending on which version of the story you read, the kingdom was overwhelmed by a spring tide either when the appointed watchman got drunk and failed to close the sluice gates or when the maiden appointed to do so was seduced by a visiting king. The story became used as a multipurpose cautionary tale: intemperance or lust, take your pick.

Beneath the waves and the morality tales there is evidence that the Cantre'r Gwaelod legend has a grounding in fact. Before the sea level rose at the end of the last ice age, around seven thousand years ago, Cardigan Bay would have been a fertile, forested plain; remnant tree stumps exposed at low tides (*see* NOAH'S WOODS) have been dated to 2500 BCE. It's possible that this and the many other deluge myths are the cultural remnants of the global flooding that profoundly changed the shape of the continents. The Sarnau are made up of material deposited by the receding ice sheets, and so are themselves a product of this reshaping process.

These were not the dykes that protected a kingdom, nor was there, in fact, much of a kingdom. There may well have been settlements up until the Bronze Age, though, and some traces may remain. In 1770, Welsh lexicographer William Owen Pughe reported seeing what he took to be the ruins of Cantre'r Gwaelod 'three or four miles in the sea between the outlets of the rivers Ystwyth and Teifi . . . I sailed over the ruins, on a very calm day and thus for about three minutes I had a clear view of them'.

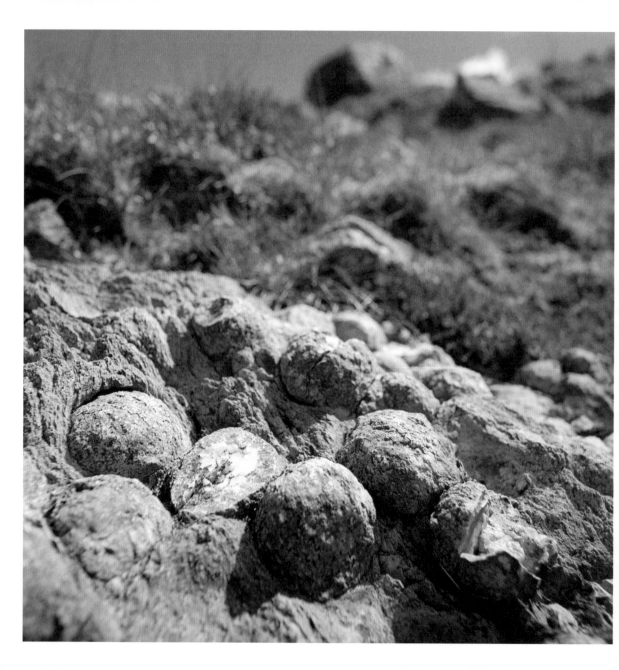

Thundereggs

There is broad consensus about the geological origins of these features: gas bubbles that form in flows of molten lava are filled with crystalline minerals harder than the surrounding rock. Many thousands of years of subsequent erosion reveal spherical rocks that can be cracked open to reveal gem-like cores.

There is an equally broad consensus about the origins of the name, but as far as I can tell it is wholly mistaken. The oft-quoted story is that a Native American tribe in what is now Oregon named these rocks 'thundereggs' believing they were the eggs of condors – known as 'thunderbirds' – and that they were hurled in anger between the gods who inhabited the summits of what are now Mounts Jefferson and Hood. In the factual hall of mirrors that is the internet, this legend has become an accepted origin of the name, but the lack of detail and context should prompt scepticism.

The tribe whose territory included Mounts Hood and Jefferson is the Molalla, now part of the Confederated Tribes of the Grand Ronde Community of Oregon. They have archivists, historians and elders, but not one of them knows of any myth relating to thundereggs. One possible explanation is that the story was invented by early rock hunters to add a touch of the (aboriginal) exotic to their sales pitch. Whether or not the legend is authentic, the sales pitch worked: in 1892 alone, $20,000-worth of thundereggs from a deposit in Oregon were sold. Notwithstanding the uncertainty around their name, the Oregon Legislature designated thundereggs the state rock in 1965.

Thanks to geology, Wales is one of a few places you can find these features outside the US and here they are known as '*wyau cerrig*' ('stone eggs').

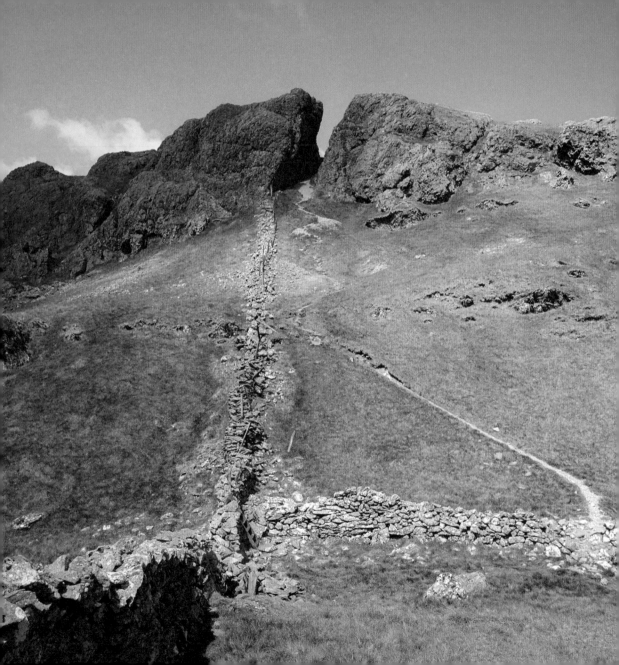

Hollt

The slate industry in Wales has its own particular and expressive terminology that varies from region to region, and from quarry to quarry. For example, in Blaenau Ffestiniog, the beds of slate are called '*llygadau*' ('eyes') and the process of opening the rock is therefore 'opening the eyes'.

The value of slate as a material is held in its layered, or 'foliated', structure, which allows it to be split into thin, impermeable layers, making it perfect for roofing and cladding. Counter-intuitively, the layers don't relate to its original sedimentation, when it settles as fine-grained clay or volcanic ash. The structure is formed later, when the sediment undergoes metamorphosis by compression and it is the direction of this pressure that determines the layering. The splitting or 'hollti' of the slates is a highly skilled process that even today is best

accomplished by hand, with a hammer and chisel. The plane of cleavage, along which a slate will split cleanly, is called the 'hollt' and so is the cleft itself. An uneven cleavage in a slate is a *hollt gynffon llygoden* ('mouse tail cleavage').

In the areas around the slate quarries of North Wales, the word 'hollt' is used for rifts in the landscape, places where the rocks have been cleft by natural forces, but in coal-mining regions of the south the word 'malc' might be found, which can simply mean 'crack' or 'split' but also particularly denotes natural divisions in a coal field. This variation is a good example of how landscape language is fed by, as much as it feeds, local vocabulary.

145

Sgwd, Rhaeadr, Pistyll, Berw and Ffrwd

Topology and climate have given Wales a good number of waterfalls in a wide variety of forms. Accordingly, the Welsh language has a variety of words for waterfall, the five most common of which are listed here. Waterfall types are distinguished in geological and geographical terminology by their shape and configuration. For example, a horsetail waterfall descends vertically in contact with the bedrock while spreading in width, and a punchbowl waterfall free-falls from a narrow spout into a pool. As with the range of Gaelic words for peaks, the distinctions between Welsh terms are not so straightforward. 'Rhaeadr', which translates as 'cascade' is the most common and widespread in use. 'Sgwd', meaning 'a shoot of water' or 'cascade' is practically synonymous with 'rhaeadr' but only used in South Wales. A waterfall of lesser volume than a rhaeadr, or one that is temporary or seasonal, is known as a 'pistyll', which can also be a spout or a fall of water under which a vessel can be filled. These are the main terms, but there is also 'berw', which has the added meaning of 'boiling, foaming or turbulent', suggesting the pool of water into which the falls flow, and 'ffrwd', a torrential flow, likely to denote a section of rapids where the water flows more horizontally.

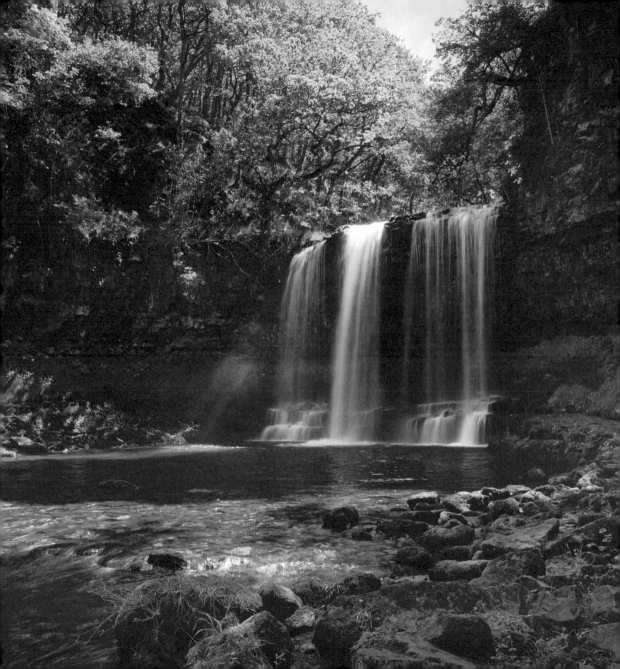

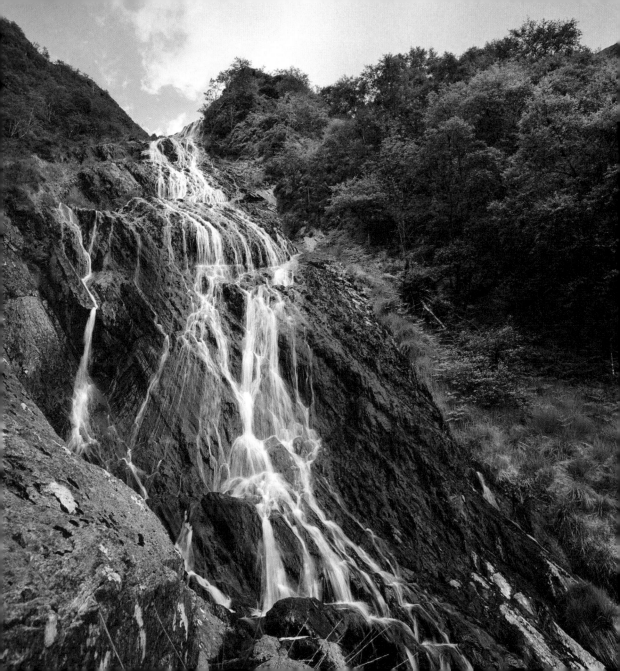

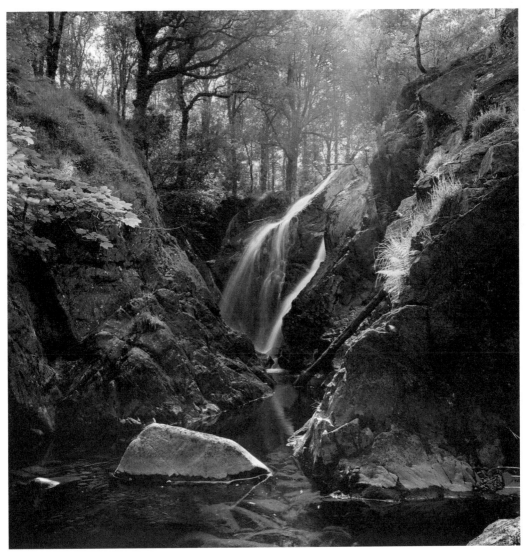

◁ PISTYLL /ˈpɪstəɫ/ △ RHAEDR /ˈrɑːɨadr/

OS: SN 753 942 OS: SN 721 244

Chalybeate Spring

Waters that emerge from the ground stained red with iron are named 'chalybeate springs' after the Chalybes, a people who lived during the seventh century BCE in what is now Anatolia. The Chalybes were associated with the mining, production and working of iron and were among the first steelworkers around the Mediterranean. They were ruled over by the Hittites, who gained a technological edge over their enemies that allowed them to establish an empire stretching across Asia Minor. Classical Greek writers including Homer and Strabo (who wrote extensively on geography) identified the Chalybes as much by their trade as by their location, suggesting that the name was attributed to a class rather than a tribe, but earlier sources suggest the Chalybes were at least originally an ethnically distinct group.

In eighteenth-century Britain, chalybeate springs were the great health craze, elevating rural backwaters such as Malvern, Harrogate, Tunbridge Wells and Llandrindod Wells to society towns, and practically inventing domestic tourism.

Woolgathering

When children were sent out to gather the snagged tufts of wool left by sheep in hedges and on fence posts it's fair to assume the task, which provides the perfect opportunity for aimless wandering, wasn't always approached with the focused attention that parents might have wanted. Hence 'woolgathering' became synonymous with absent-minded daydreaming and generally letting one's mind wander from the matter in hand.

Even performed with a good measure of dilly-dallying, woolgathering in its original sense could return results. On posts, trees and stone walls – anything a sheep might have rubbed against or squeezed past – it's likely you'll find shreds of fleece blowing in the wind. These strands build up on wire fences like thread on a spindle. I've often wondered whether these things have a name: surely the child woolgatherers must have called them something. I've not had much luck finding

any words, so I've been driven to speculation. The Welsh language is well-stocked with words relating to sheep and wool, and two of these are particularly well suited to repurposing.

'Casnodyn' is not a word in general use these days, but according to William Owen Pughe's *A Dictionary of the Welsh Language* (1832) it means: 'a flock of wool' ('flock' here is used in the sense of a 'lock, tuft or shred of waste fibres'). 'Cotwm', from the same source, means 'dag-wool; cotton'. Although 'dag' has been taken up by the sheep farmers of Australia and New Zealand to refer to the crud-clotted clumps of wool around a sheep's backside, its original meaning was the more general 'hanging lock'. 'Cotymog', a derivation of 'cotwm' meaning 'having dags or locks' would be my choice, as in: 'the fence was cotymogged like woollen bunting', or 'the cotymogs quivered in the wind.'

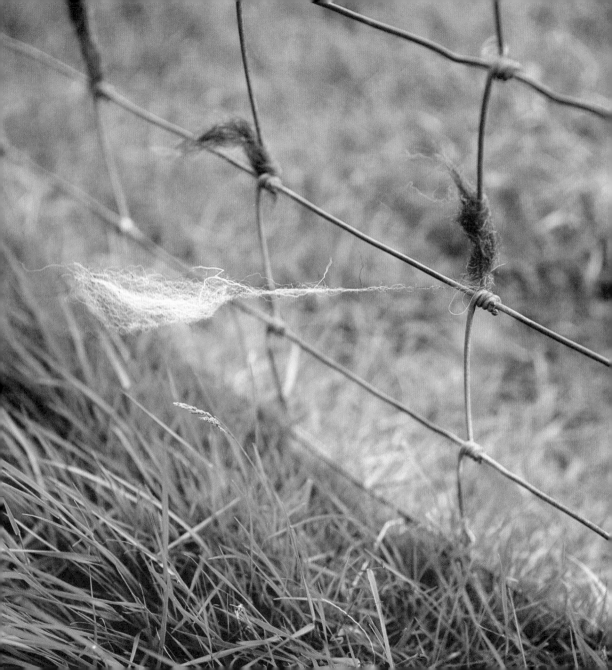

SHIRES

This region is as much conceptual as it is actual. Shires were originally Anglo-Saxon administrative districts, created to simplify the business of taxation, and in modern use 'the Shires' usually refers to those counties that end with *-shire*, a nebulous collection since many, like Devon(shire), Dorset(shire) and Rutland(shire), only keep their long forms for special occasions and tourist-board promotions. Even excluding these part-time shires, this group has no more of a collective identity than any random selection of counties.

So where are the Shires? I think their most vibrant home is in the imagination, where they exist as a kind of comfortable middle England of village greens and pleasantness: a confection of loosely knitted concepts such as fair play and decency and moderation in all things. It's no coincidence that Tolkien named his Hobbit homeland 'the shire', since it was there that he conjured a utopia of mild good-living and bucolic contentment that resonates deeply in the British, and particularly in the English, psyche. But all this conceptualising doesn't mean that shires have no physical existence. There may be no easily defined geographical area that corresponds to these ideas, but we do seem to recognise certain qualities in the landscape that seem shire-like: rolling hills and wooded valleys, meandering rivers and old pathways, and what it lacks in drama it makes up for in repose.

In search of the shire of my imagination, I walked the newly inaugurated Laurie Lee poetry trail in the Slad Valley, Gloucestershire. Lee's writing – both prose and poetry – drew heavily on his childhood in the woods and fields of this valley. In the autobiographical *Cider with Rosie* he recalls his first, traumatic, immersion into the countryside aged three, when his family moved from nearby Stroud.

The June grass, amongst which I stood, was taller than I was, and I wept. I had never been so close to grass before. It towered above me and all around me, each blade tattooed with tiger-skins of sunlight. It was knife-edged, dark, and a wicked green, thick as a forest and alive with grasshoppers that chirped and chattered and leapt though the air like monkeys.

Lee's eye for natural detail was acute, perhaps sharpened by this early feeling of peril and

preserved by the sense of foreign wonder that came afterwards.

The fields and woods of the Slad Valley have changed little since Lee's arrival. In July, when I walked the trail, the grasses in the meadows were high enough to be a jungle for any child and the chattering grasshopper 'monkeys' sprang like tripwires wherever I walked. On the thistle flowers and the cow parsley were cinnabar moths, their black-and-scarlet wings as sombre and martial as Remembrance Day. At that point in the summer, the blazing sun seemed to be heating the day from scratch rather than topping up its previous efforts, and when an occasional cloud passed over, the temperature dropped sharply. Under the trees the air was cool but carried a warm, earthy musk up from the ground. The beech leaves, filtering and radiating light, seemed to fizz with oxygen at their downy edges. All living things were fully operational, all processes at full capacity, humming like a vast, contented machine.

The bumblebees I stalked were clearly part of this bustling contentment, buzzing in resonance with the deeper vibrations. As a child in Methodist Sunday school I once constructed an ontological argument for God based on the news, which I'd heard on the radio, that scientists had analysed the aerodynamics of bumblebees and calculated that they 'couldn't fly'.

This oft-repeated 'fact' is now recognised as pseudoscience, but at the time it seemed to me the only explanation for this loophole was that God, in his infinite wisdom, was letting bumblebees fly by bending the rules of physics for them. If I'd created bumblebees and then found I couldn't get them to fly because of a technicality I would have cheated too. My Sunday school teacher was a little startled by my theory. I think she might have suspected that, like most of my contributions, this too was somehow heretical but she couldn't quite work out why.

In the Slad Valley the blackberries were coming on fast and early. The sun was making good progress too, and the heat was spreading into the shade like it meant to stick around. The trail led down the valley and up the other side before looping back to the main road towards Stroud. I left the trail and, joining the road, walked to the Woolpack Inn, where Lee had been a regular in the 1960s after his return to the village of his youth. It was the proceeds from sales of *Cider with Rosie* that enabled him to buy a cottage here. On his return he wrote *As I Walked Out One Midsummer Morning*, which begins with an account of his departure from the village in 1934. I sat with a pint in the pub garden and tried to make intelligent notes but it was hot and I was drowsy, and if Lee's presence lingered it wasn't imparting his eloquence.

Among my jumbled notes I wrote the word 'nostalgia'. At the time I was thinking about how many pubs are renovated to look older, complete with ersatz tobacco-stained ceilings. This wistfulness for the 'good old days', though no one agrees on when exactly those were, follows us like a retinue, always keeping the same distance behind. Stories are told and retold until they become part of a fallible shared memory. More often than not we are sentimental about something that never actually existed, or something that has become changed in the process of retelling. These narratives say more about the way we are now than the way we were then. They are stories that we tell about ourselves to reinforce our sense of identity. My Sunday school bumblebee story is like this. I like to tell it because I think it makes me look good and because in those days I wasn't afraid to think big.

'The Shires' is a story we tell about the English landscape, and it may have been misremembered and elaborated but the fact that we still tell it is important because it suggests that it's doing something useful. Tolkien and Lee both went to war as young men; maybe these experiences crystallised a sense of homeland that was largely nostalgic. The story they told, one through fiction and one through memoir, was of a place where memories settled comfortably, if not accurately. In doing so they were preserving something that they felt was under threat from change, whether in war or peace. When I reread *Cider with Rosie* recently, I was surprised by the number of horrific events that punctuated Lee's childhood. In the book, Slad is the backdrop to murder, rape and suicide, but I, under the spell of my own sentimentality, had remembered only the bucolic bliss and the familial warmth. And this, I suppose, is the danger of nostalgia: it preserves by sweetening – like jam – so the bitterness and sourness of the past are too easily forgotten.

SCOWLE /skaʊl/

RELATED TERMS: swallet, dean, dene

OS: SO 604 046

Scowle

In and around the Forest of Dean there are places where the ground is a labyrinth of rifts and hollows, deep pits and tree-topped banks. These features are particular to the area and known locally as 'scowles'. For a long time they were believed to be the remains of ancient iron diggings. However, recent excavations have suggested that while the scowles were clearly exploited for their iron-ore deposits, their structures were formed as a natural underground cave system in the limestone that was later exposed at the surface. While exploring a scowle near the town of Bream I felt a sudden insecurity in my sense of scale. These landscapes resemble both the epic and the microscopic in form; one minute I felt like a giant striding through a diminutive mountain range, while the next I could easily imagine I was the size of a mouse and that the deep ditches and steep banks were the crevices and ruts of a forest floor. Leaves and branches from the beeches above collected in deep litter in the crevasses, perfectly camouflaging what might be a natural tiger-trap. If you did find yourself in such a pit, climbing out would be made near impossible by the soil that bears the deep ochre hue of haematite and crumbles like rust.

Their topographies make scowles a rich and seldom-disturbed habitat for plants, invertebrates and small mammals, especially bats. Sitting quietly in a scowle, waiting for the sun to come around, I started to notice more and more rustlings in the leaves until eventually five or six shrews broke cover and started to play a game of kiss-chase around my tripod.

As a young man, J.R.R. Tolkien worked on an archaeological dig at Lydney Park, which contains several scowles, and it's not hard to imagine that many of the fictional forests he later created owe something to his memories of these landforms.

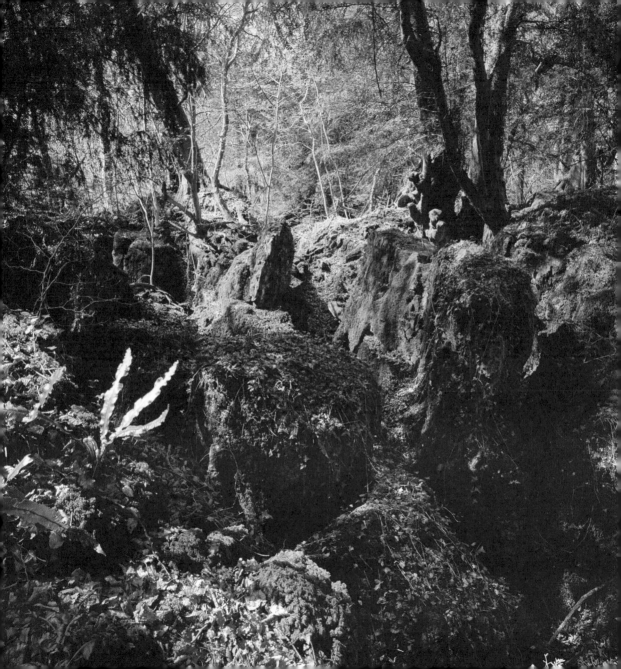

Copse

A copse is woodland that is, or has been, managed by coppicing. We might think of British woodlands of the past as wild and untamed places, filled with wolves and bears and ancient menace. In fact, the forests have been managed and harvested for timber for many centuries; excavations of Neolithic tracks on the Somerset Levels have provided some of the earliest evidence of this woodland management. The tracks were built from a mass of long, straight branches that could only have been produced by coppiced trees.

Coppicing involves cutting the main trunk of a tree and encouraging new shoots to sprout from the stump, or stool. The multiple stems that result tend to grow longer and straighter than the tree's original trunk, and can be harvested when they have reached the desired size. Practically all broad-leaf deciduous trees can be coppiced, though some are more productive than others. A coppiced hazel can produce a yield of timber every seven to ten years compared to every 30 years for oak and ash. A variant on this practice known as 'coppice with standards' mixes coppiced trees with individual specimens that are allowed to grow to maturity unaltered. Woodland managed like this gives a constant supply of timbers, small and large, for a variety of uses. Until well into the nineteenth century this kind of forestry was the prime mover of British industry, providing fuel for smelting iron, materials for manufacturing, timbers for shipbuilding, and bark for tanning and dying.

The rarer synonym 'copy' may have arisen from attempts to make the perceived plural 'coppice' (coppies) into the singular (copy).

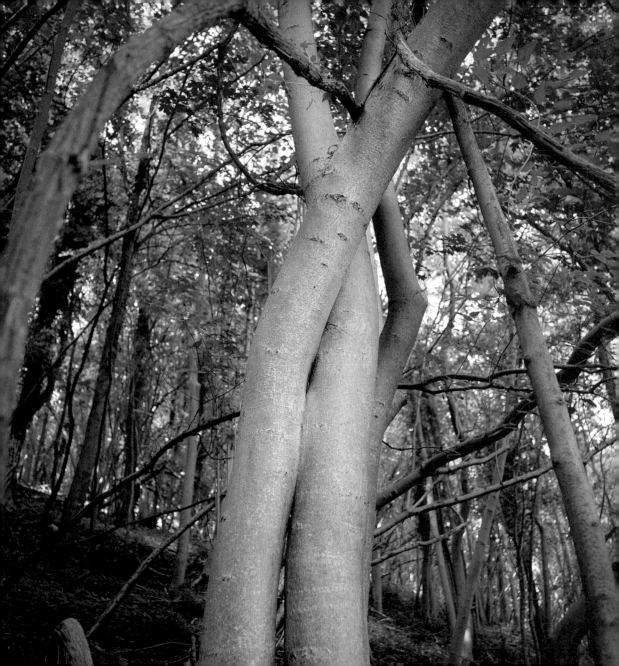

Inosculation

If two branches of a tree rub against each other so that their bark is worn away and their cambium (the layer of vascular tissue) is exposed, they can unite in a natural graft. The resulting forms often resemble a loving embrace, and the word for this phenomenon – 'inosculation' – is fittingly derived from Latin 'osculāri': 'to kiss'. Inosculation can occur in branches or stems of the same tree or, in the case of the romantically titled 'husband and wife trees', those of neighbouring specimens.

Pleaching is the weaving together of living plant stems to create garden features, a practice which, over time, can result in inosculation. In the 1940s, the Swedish-American farmer and amateur horticulturalist Axel Erlandson crafted a number of tree-sculptures through pleaching and grafting. His Tree Circus became a popular tourist attraction and contained an extraordinary range of seemingly impossible forms, including a 'Telephone Booth Tree', which is now an exhibit at the Visionary Art Museum in Baltimore.

Dumbledore

The bumblebee has been known by many names in Britain, including 'drumbledrane', 'foggy bumbler' and 'dumbledore'. All of these names share an onomatopoeic allusion to the bumblebee's sound. The Latin name for its genus, *Bombus,* means 'buzzing', and this word also gives us the term 'bombilate', meaning 'to buzz, especially by means of rapid vibration'. Surprisingly, the buzz of a bumblebee is not created by its wings but by the muscles that power them, and you can check this for yourself by watching and listening as one feeds on a flower. Just before the bee takes off, and before its wings start to flap, it begins to buzz as it warms up its muscles – like a helicopter firing up its engines.

'Bumblebee' might be the most common term today, but 'humble-bee' was more widely used until well into the twentieth century. Darwin mentions the role of pollination by the humble-bee in *The Origin of Species*, and the 1912 master text on the genus written by Frederick Sladen was unequivocally titled *The Humble-bee: its life history and how to domesticate it.* Beatrix Potter, however, opted for 'bumble' in the 1910 *Tale of Mrs Tittlemouse,* and by the mid-1900s 'humble' was out and 'bumble' was in. This might be seen as a measure of the relative cultural influence of works of science and works of children's literature.

Coincidentally, another Potter has played a part in returning this name to popular consciousness. In J.K. Rowling's *Harry Potter* series the redoubtable headmaster of Hogwarts is Professor Albus Percival Wulfric Brian Dumbledore. Professor Dumbledore, however, doesn't live up to his name as used in the West Country, where it's an old dialect term for a person who is slow, lethargic and rather dim.

Will-o'-the-wisp

Whether known by this name or one of its many regional aliases, this glowing apparition has resisted explanation for centuries and continues to do so today.* Appearing at night and seeming to float on the mist over marshes or in woodland, these lights can lead to terrible dangers or wonderful treasures, depending on the story. To be 'will-led' is to find oneself unable to resist temptation or curiosity and therefore be drawn towards whichever fate lies at the end of the journey.

Swamp gas, bioluminescence and ball lightning have all been suggested as natural causes, but attempts to recreate the phenomenon under controlled conditions have been inconclusive. Unless there's a good chance of discovering a new source of cheap, clean power, or a treatment for disease, or at a push a hitherto-unrecorded life form, I'd be inclined to let the matter rest unresolved. As William Holloway wrote in *A General Dictionary of Provincialisms* in 1839:

...in the days of ignorance and superstition, what ever appearance in nature was incapable of explanation as to its cause or origin, was immediately referred to the agency of some unseen spirits, the most harmless of which the fairies have always been considered. Though the light of truth is to be preferred to the darkness of ignorance, yet none will attempt to deny that to the tales of fiction, arising out of that darkness, we are indebted for many of the happiest illusions in life.

For me, and others of my generation, this term is forever associated with the many voices of Kenneth Williams, thanks to his tour-de-force narration of the 1980s BBC cartoon of of the same name.

* Including Hobbedy's-lantern in Worcestershire, Warwickshire and Gloucestershire; Hinkypunk in Devon and Somerset; Joan-in-the-wad in Cornwall and Somerset; Spunkies in the Scottish Lowlands; and Ellylldan in Wales. Jack-o'-the-lantern was once in widespread use in the UK and is the origin of jack o' lantern in North America.

Wellum

This term appears in the *Dictionary of Newfoundland English,* published in 1982, which is a particularly rich resource of words from the fishing communities of eastern Canada. Many in these communities were British immigrants who brought their language with them to the new world, using words in their adopted homes long after they had all but disappeared from their place of origin. 'Wellum', sometimes spelled 'willem', is a word for the radiating ripples set off by a surfacing fish.

I have seen many wellums, but hardly ever seen the fish that made them. They are what you see when you turn to the sound of the plop; what the quivering branch is to the birdwatcher and the swaying curtain of grass is to the deer hunter. They are a sign of absence as present and as poignant as a closing door.

Meander

A section of river that winds and loops and cuts back on itself is known as a 'meander'. Having derived from the name of a notably convoluted river in ancient Turkey, the word came to be used for all kinds of serpentine forms, both literal and metaphorical, although its particular application to rivers has endured.

As a verb, it describes the sort of aimless wandering that can be infuriating if you are in a hurry to get where you are going. River waters seem to express this frustration by breaking through the loops of a meander and creating shortcuts. When this happens, the now-redundant loop can become isolated from the main river, thereby forming an oxbow lake. The impatient flow of water makes a river meander a much more dynamic formation than the name might imply, and they are constantly changing due to fluid dynamics and sedimentation. If you were to view the course of a meander over several hundred years you would see it flex and undulate, moving gradually downhill like an enormous snake.

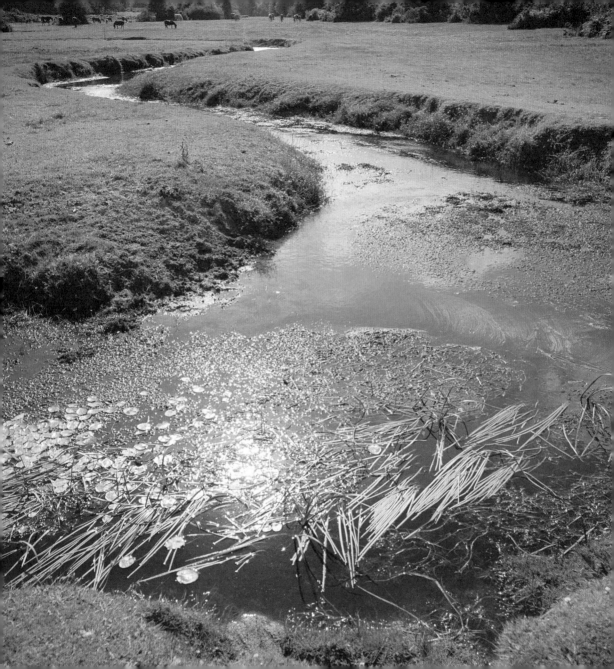

HOLLOWAY

/ˈhɒləʊweɪ/

RELATED TERM: desire
path

OS: SO 879 074

Holloway

These are the paths that are carved deep into the land by the footsteps of countless people and beasts, and are often so canopied by trees that they resemble tunnels bored out of the woodland by some great and relentless beetle. For a holloway to endure it must strike a delicate balance. If it is too well-used then it may be adopted, resurfaced, widened and tamed. If it is completely abandoned then it will quickly return to the wild. London's Holloway Road might be the quintessential example of taming. The road that now brings the A1 into the city was once the main drovers' road to Smithfield market from the north and would certainly have carried the volumes of traffic likely to wear into the earth, but the derivation of its name is uncertain, another theory is that the name comes from 'hallow', denoting significance as a pilgrimage route. Traces of holloways that have gone feral can be found all over the country, as a pair of raised banks cutting through woodland, a ditch or an avenue of trees. Holloways can feel like dried-up rivers or houses left empty. They were created by and for the traffic they once carried and now that it has gone they are haunted by it. It's hardly possible to walk a holloway without a sense of the travellers and journeys of the past: they are passages of time.

Stunpol

There's an old woodsman's adage that a tree spends the first third of its life growing, the next third standing and the last third dying. In Dorset, trees that are well into this final third are called 'stunpols'. These trees are often partially dead and broken-down. Their hearts are sometimes hollowed with rot (*see* DADDOCK) and when their upper branches have shed leaves for the last time and remain bare as antlers they are said to be 'stag-headed'. Though such trees are much admired for their sculptural qualities and for their sense of dignified grandeur, to call someone a 'stunpol' is to imply profound decrepitude.

Extending the growing phase of a tree's life by coppicing (*see* COPSE) dramatically lengthens its overall lifespan: most of the oldest living trees in Britain have been coppiced.

Daddock

This is a dialect word for 'rotten wood' that has variants in the counties of Dorset, Berkshire, Gloucestershire and Wiltshire. Daddock implies a dry, crumbling rot that might hollow out the heart of a once-great tree or desiccate standing deadwood to provide tinder. Some of the old dialect dictionaries give 'daddock' as a synonym for 'touchwood', a word derived from the Old French *toucher* meaning 'set fire', hence 'touch-paper'.

The adjective 'daddocky' is primarily applied to trees and timber, but seems to have occasionally found its way into more general use for something weakened or compromised through age and decay. Wiltshire variants 'daddick' and 'daddicky' might be the origin of the adjective 'dicky', meaning 'unsound, feeble or in poor condition', in which case there is a neat parallel between the fragile heart of a rotten tree and the later use 'dicky ticker', applied to a fragile heart of a person.

Briar

In figurative use, a 'briar' or 'briar-patch' is an intractable problem or a situation from which extrication seems impossible. If you have ever experienced that moment in the pursuit of blackberries when greed overcomes both caution and your sense of balance, then you will know how appropriate this allusion is. The word 'briar' derives from an Old English word for prickly plants in general, though over time its use has narrowed to members of the Rosoideae subfamily, which includes brambles and, in particular, wild roses, one species of which is called 'sweet briar'.

From a botanical point of view, none of the members of this family of plants have thorns, instead they have prickles. Strictly speaking, thorns are developed from shoots and connected by vascular tissue to the plant, whereas prickles are not: they will come away from the stem cleanly if broken.

Brambles are notoriously tough and vigorous plants, spreading out long, exploratory branches that can grow up to nine metres in a year. These colonists will take root and set flowers in their second year, if their tips find suitable soil, allowing the plant to occupy available land quickly. Trailing 'brambles' are a common sight atop the embankments of suburban roads, and I've often noticed that where they have been swung back and forth by the wind, their prickles have etched patterns into the accumulated grime on the concrete. Compared to the graffiti tags, with which they often share a canvas, I see these 'bramble-arcs' as the plants' more subtle markers of identity and voice.

Monkey's birthday

Simultaneous rain and sunshine is a fleeting affair. It's a good time for rainbows, of course, but also for spectacular natural light – the ground illuminated through curtains of silver rain and the sky storm-dark and turbid. It is a spectacle that makes you think something strange is about to happen, and perhaps for this reason it has been given unnervingly similar names in a wide range of cultures around the world*. In parts of Dorset and Somerset it's known as a 'monkey's birthday'. In other countries, animal nuptials seem to feature widely: there are versions of 'fox's wedding' in Bangladesh, Brazil, Finland, Japan, Italy and Portugal. Bulgarians replace foxes with bears, for the Koreans it's tigers, and the equivalent phrase in Arabic is 'the rats are getting married'. In France and Morocco it's a 'wolf's wedding'. South Africans can choose between the Zulu 'wedding for monkeys', and the Afrikaans 'jackals' wedding'.

Hell and the devil are also common. The Dutch and Germans have versions of 'there's a party going on in hell'. In the pidgin English of Vanuatu it's 'ol devel oli mared' or 'the devils are getting married', an identical phrase to the one used 9,500 miles away in Abkhazia. The Hungarians say 'the devil is beating his wife', and variations on the theme of demonic domestics abound in the US, where there are even associated instructions on how to listen in to the commotion: by putting your ear to a pin in the ground, or a rock, or a horseshoe wrapped in cloth on the ground.

In Russia they call it 'mushroom rain', which for me conjures images of nuclear fallout, but which is presumably because the combination of warmth and moisture is good for fungus. Hawaii has my favourite phrase - 'ghost rain', which I think captures the weird atmosphere of this phenomenon beautifully.

* Many of these phrases were collected by Bert Vaux, Professor of Linguistics at Harvard, from responses to a 1998 online post calling for examples of idioms associated with 'sunshowers'. Full details are available at www.linguistlist.org

SOUTH EAST

Estuaries share the uncertain character of borderlands. At the junction of the tidal rhythm and the flow of the river the currents can be unpredictable and inconstant, even where the surface remains impassive. On the stretch of coast from the Medway to Ipswich, which cuts through the clays of the London Basin, the land responds to the pressures of the sea with a pattern of capitulation and reformation. Erosion cuts and widens the inlets and creeks while sediment is deposited to form bars and spits, jutting like barbs into the sea. The estuaries of the Medway, Thames, Crouch, Blackwater and Colne, Stour, Orwell and Deben all meet the North Sea along the London Basin; on maps their broad channels resemble invasive roots reaching inland. Walking near the Blackwater estuary, I began to appreciate how this give and take has produced a landscape of endless convolution. Points that appeared to be close were made distant by paths that twisted and turned to accommodate the ingress of the sea upon the land as well as vice versa. Depending on the direction of the wind I could smell the thick rot of seaweed or the thin, musky funk of cow parsley. This environment, with

its caul-fat pattern of creeks and saltings, where even the scent fluctuates between land and sea might confound the earthbound, but for waterfowl and insects it's seamlessly accessible, and offers food and shelter in abundance.

Often borderlands are forsaken places, but this estuary was well-patrolled by wildlife. Guillemots, terns and petrels flew sorties over the water, egrets and herons stalked the shallows on watch, and all manner of geese and ducks swam in flotillas on the ponds and lagoons. Adding a hint of real menace to this semblance of a joint military exercise, two low-flying Apache helicopters from nearby Wattisham Airfield made occasional appearances: banking, hovering and swooping – monstrous dragonflies above their miniature cousins. Whenever I stopped for more than a minute or two, a cloud of midges caught up with me and hassled me until I set off again. This place was teeming with activity but practically empty of people. I only saw one other human, a birder with a scope and tripod, in the space of five hours.

Before the eighteenth century, the only people who would have been seen walking in the

countryside were vagrants and the rural poor. It's hard to imagine it, but three hundred years ago there simply was no aesthetic or therapeutic value given to nature and the experience of being outdoors. Attitudes began to shift when two concepts that emerged from the Romantic movement made their way into the public consciousness. The first was the idea of the sublime, developed by the philosophers Burke, Kant and Hegel in the eighteenth century, an aesthetic response that went beyond a rational appreciation of beauty to include emotional reactions such as awe and even horror. The second was the idea of the picturesque, which reframed the concept of landscape through this new aesthetic sensibility. The picturesque in art was an attempt to capture the epic power of the sublime while retaining the sense of harmony and balance of classical notions of beauty. Artists of the Romantic period approached the natural landscape with a renewed fervour, seeing in it a subject as worthy of their attention as any allegorical scene. The writer and artist William Gilpin was most influential in applying these new ideas to the British landscape. His illustrated journals of tours in the Lake District and South Wales drew the attention of an audience who were well-acquainted with the great views of the continent to the beauty on their own doorsteps. Before long this rebranding was changing people's feelings towards the countryside. The vagrants and the poor now had company on the footpaths as the leisured classes gave up the Grand Tour and took to the hills and valleys to seek out the sublime vistas of Britain.

In the last few decades, a growing appreciation of so called 'liminal' spaces has driven attention to the overlooked edges of our cities, much as ideas of the sublime and the picturesque did for the countryside. These threshold spaces between city and suburb, suburb and countryside, countryside and industrial estate, are celebrated for their aesthetic and environmental value. Perhaps 'celebrated' isn't quite the right word; the mood around this exploration of the overlooked urban wasteland is pretty low-key and ever-so-slightly furtive. In fact, one of the main features of the spaces I consider liminal is that I'm not sure whether I'm allowed to be there or not. They are often areas that have no physical barrier to entry and yet are palpably different from public spaces. In such places you can easily imagine goings-on that, if not illegal, are in some way outside social norms. One of the first writers to re-evaluate these hinterlands was Richard Mabey, whose 1970 book *The Unofficial Countryside* recorded the abundant ecosystems that thrive on the margins of the city. This book was perhaps the first work to turn a naturalist's eye on the overlooked suburbs. For a long time we have had a very restricted idea of

what the 'natural landscape' is, and by extension of where we should go to see it. This was, in part, formed by the Romantics – when they elevated the landscape to the status of an artist's muse they did so selectively. And when, in 1949, the National Parks and Access to the Countryside Act was brought to the statute books, those same landscapes were selected for special treatment. In many cases our perception of what 'natural landscape' even looks like is simply a snapshot of a particular moment in the countryside's history. George Monbiot makes this case in his book *Feral,* arguing that instead of trying to preserve the natural environment in a static state that corresponds to a particular arbitrary baseline, we should return it to a dynamic state from which it can develop freely. It's often the marginal spaces and the frayed edges that by virtue of being ignored and unkempt are the most dynamic, and this is why nature abounds there.

The extent to which plants and animals thrive in the wastelands of our cities is, for me, a source of profound comfort. Every time I see a shoot breaking through a crack in the pavement I'm reassured that there is a more potent force than concrete.

Dell

This word, unchanged from Old English, has always had much the same meaning: a small valley or hollow, usually wooded. When large forests were felled to clear land for agriculture, pockets of woodland were often left in the dells, where the topography made the job of clearing and the practice of farming more effort than it was worth. Dells can also be areas contained within larger woodlands, like Bunyan's Dell in Herefordshire (*pictured*). Named after John Bunyan, author of *The Pilgrim's Progress*, who held his illicit, non-conformist moonlit services here for what he called his 'gathered church'. When occupied by a congregation reported to number over a thousand, this tree-fringed bowl must have buzzed with excitement, no doubt heightened by the dark and the danger of being discovered by the authorities.

Edward Foster, a local man whose grandfather sheltered Bunyan, wrote this account in 1853 of the meetings he heard about as a young child:

Here, under the canopy of heaven, with the rigour of winter's nipping frost, while the clouds, obscuring the moon, have discharged their flaky treasures, they often assembled while the highly-gifted and heavenly-minded Bunyan had broken to them the bread of life.

The synonym 'dingle' has an uncertain origin but was brought into literary use by Milton in his 1634 work *Comus*:

I know each lane, and every alley green
Dingle or bushy dell of this wilde Wood,
And every bosky bourn from side to side

A 'bosk' is a thicket or little wood, hence a 'bosky bourn' is a stream ('bourne') shaded by trees. 'Bosky' was also a word used for a state of mild inebriation, perhaps drawing a parallel between a confusion of mind and a tangle of branches.

Witches' Knickers

This is a wonderfully evocative and gently satirical term for the tattered scraps of plastic bags that get snagged on barbed-wire fences and in shrubs and trees. Originating in Ireland on the cusp of the new millennium, it's the newest bit of colloquial language in this book by a comfortable margin, but it's one that follows a long tradition of idioms that allude to the occult: dragonflies as 'devil's darning needles', for instance, and witches' broom (*see* p. 79).

In the film *American Beauty*, the dance of a single windborne bag becomes an emblem of unexpected joy but, en masse, witches' knickers provoke less positive emotions. Faced with a widespread blizzard of polythene, Ireland introduced a plastic-bag tax in 2002 to combat the problem, a move which led to a ninety per cent drop in per-annum consumption.

Errant plastic bags are a worldwide phenomenon, and the Irish are not the only people to have given them a satirical name: in Alaska they are called 'tundra ghosts', and in South Africa they have been sarcastically named 'the national flower'

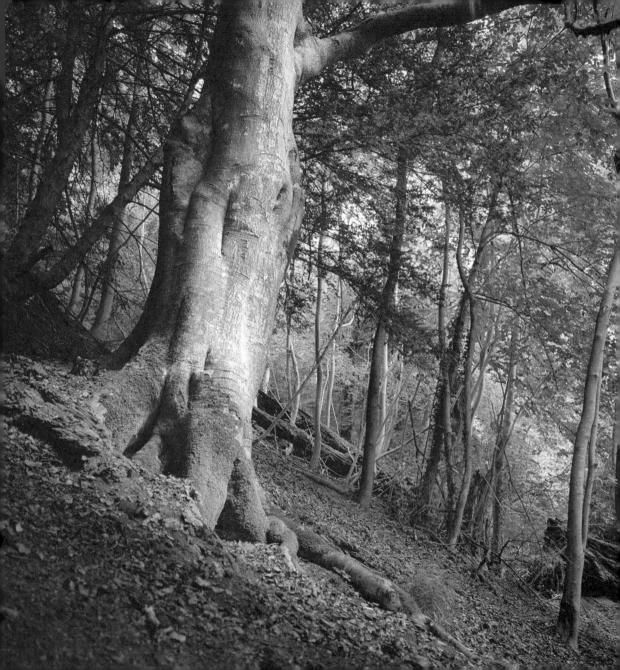

Hanger

Clinging to the steep chalk slopes of the North and South Downs and the Chilterns are woods called 'hangers'. They are dominated by beech trees, which, thanks to their root structure, prosper on the thin, free-draining soil. Very few tree species, even when fully grown, have roots much deeper than three metres, but the root system of a mature beech is even shallower than most. To compensate for the lack of depth, the beech spreads its roots wide, developing buttresses for stability and increasing its catchment of rainwater. A beech can get all the moisture it needs from the uppermost metre of soil, which is a huge advantage in a hanger, where water drains through the earth quickly and runs off down the hill.

The hanger pictured opposite is a close neighbour to Selborne Hanger, of which the 'parson-naturalist' Gilbert White wrote: 'The covert of this eminence is altogether beech, the most lovely of all forest trees, whether we consider its smooth rind, or bark, or graceful pendulous boughs.'

Hangers and other beech woodland in the South East was historically important as a source of timber for furniture. In 1725, a touring Daniel Defoe noted that the beech woods of Buckinghamshire were 'more plentiful than in any other part of England', yielding timber for 'diverse uses, particularly chair-making and turnery-wares'. By the time manufacturers such as G Plan, Parker Knoll and Ercol were setting up in High Wycombe, the area had long been established as the heart of the British furniture industry.

The qualities that make beech such an important timber for furniture making – its close grain, strength and ease of working – also make it the common choice for the manufacture of coat hangers.

Cowbelly

In the wide, slow meanders of rivers, where the current slacks to near stillness, the finest sediments carried in the water are allowed to fall to the riverbed, where they form a silt as soft as a cow's belly, hence 'cowbelly'. These sediments are so subtle that the layer in which they are suspended lies between a liquid and a solid state. Bare toes entering a cowbelly would register a change of temperature before a change of substance, from silky water to silky mud.

A summer day that I spent beside the River Lynher with my friend Nicky and his family has stuck unusually firm in my usually flaky memory. A triptych of strong sensory experiences left their mark. I remember the feel of the cowbelly under my feet as we waded out to a deep pool that was held in the crook of the river bend. I remember the taste of hotdogs, sun-poached in their can,

which we ate briny and dripping in our feral fingers, juddering with cold from swimming. Then there was the sight of Nicky's mum sunbathing. I can't remember whether or not she was topless, which would have added a pre- pubescent frisson; I do remember that her skin was as smooth and tanned as the frankfurters'.

I didn't have a word for any of these experiences that day, and even now I would struggle to name the first two: 'junk-food-joy' and 'proto-lust' describe but don't evoke. When I read the definition of 'cowbelly' for the first time in *Home Ground: Language for an American Landscape* it was instantly familiar. It retrospectively named the experience so perfectly that it's hard to believe I didn't always know the word, and I will always associate it with the nitrate tang of the hotdogs and the unsettling magnetism of exposed skin.

AIT /eɪt/

RELATED TERMS: eyot, ayot, holm

OS: TQ 194 776

Ait

These are river islands, in particular those on the Thames. Some aits (or the variant 'eyots') are small, little more than a few trees and rocks; others are big enough to have been built on. Of these larger aits – Eel Pie Island, previously called 'Twickenham Ait' – is notable as the location of the Eel Pie Island Hotel, which transformed from a tea-dance venue in the early 1900s to the throbbing heart of the British music scene in the 1960s, hosting legendary performances from Pink Floyd, The Rolling Stones and The Who, among many others. The hotel was forced to close in 1967, was occupied by a hippie commune in 1969, and then burned down in 1971.

The ait pictured opposite is Oliver's Ait near Kew, previously known as 'Strand Ayt' and thought to have been renamed after Oliver Cromwell. Aits seem to cradle rebellious spirits and have been places of sanctuary from early settlements through to the present day. In 2010, the BBC broadcast a report about a pensioner who claimed he was living rough on Chiswick Eyot despite it being inundated regularly by high tides. When interviewed by the reporter, his neighbours in this most exclusive district of London seemed remarkably supportive: 'I think it's terrific if he enjoys it,' commented one, before adding that he 'probably sees a lot more of the wildlife than we do', which does slightly suggest a confusion between birdwatching and homelessness. When the island's owners, Hounslow Council, sent someone to investigate the report, they found no sign of any inhabitant.

The origins of the word are uncertain but it probably derives from the Old English '*īeg*', meaning, 'island'.

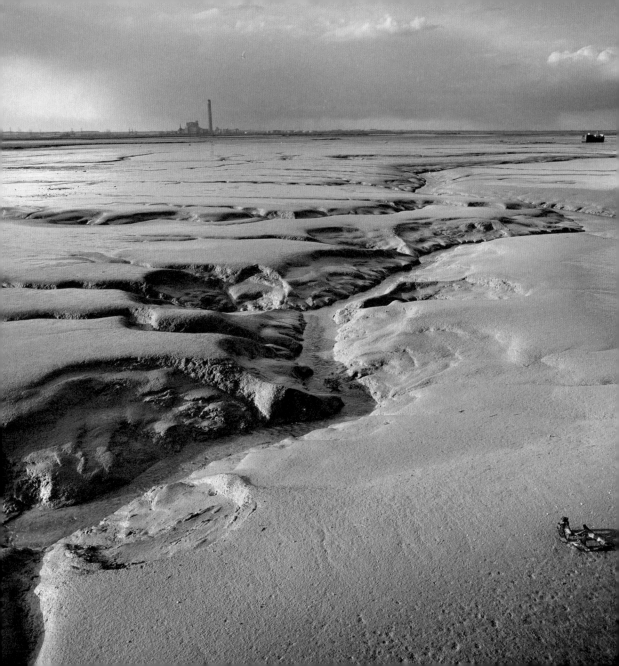

OOZE /uːz/

RELATED TERMS: mud,
fleet, crike

OS: TQ 842 699

Ooze

Ooze is as ooze does: between toes, under the keel of a boat and over wellies. This term for a mudflat is one of many landscape words that impart something of the essential nature of the thing it names. It's an evocation that arises from the confluence of two Old English words: '*wāse*' for 'mud' or 'slime', and '*wōs*' for 'sap' and hence 'to exude'. By chance or linguistic selection both words have evolved to 'ooze', and the ambiguity between the two meanings produces a word that does so much more than merely denoting.

Walking along the edge of Ham Ooze on the southern shore of the Medway I noticed that each squelching footstep was followed by a barrage from a battery of what looked like under-powered water pistols, just on the surface of the mud. The flat, barren sludge was obviously full of life. What I'd taken for small rocks were actually heavily encrusted oyster shells as big as my open hand. Delicate worm casts, like miniature Gaudí outhouses, were everywhere, as were the keyhole-shaped indentations of razor-clam burrows, and when I dug quickly enough to catch them I found carpet clams buried in the mud wherever their tell-tale squirts gave them away. Had I not been uncomfortably close to a sewage works I would have gathered a few for spaghetti vongole.

Organic material in the river sediment makes for nutrient-rich mud, and as a result oozes can support complex and extensive food chains from microscopic organisms to molluscs and worms to fish and wading birds. An oft-repeated, oft-adjusted statistic claims that a cubic metre of estuary mud contains food equal in calories to fourteen Mars bars, or fifteen, or sixteen depending on either where you read it, or (perhaps) on the prevailing size of Mars bars at the time.

Saltings

Being neither land nor sea they are immune from the trespassing of man, who can pass them neither on foot nor by boat without much knowledge of tides and the treacherous customs of the genius of the place. Careless disturbers of the peace rarely trouble the saltings; no one comes to them but of set purpose, and no one lingers on them when his business is at an end.

EMN, *Spectator*, 3 June 1927

Saltings are coastal marshes made up of complex networks of small islands and muddy creeks that are inundated and drained daily by the rising and falling tides. Without vegetation, saltings would become shifting mudflats, unable to resist erosion. Yet even with the added stabilisation of roots and the protective cover of grasses and low scrub, the topography of saltings changes constantly, if slowly.

From above, saltings look like a blobby labyrinth, a marbled endpaper of brown and green, and even with the benefit of overview it can be difficult to work out a route from A to B. On the ground, navigation becomes even more challenging, as apparently direct paths turn out to be blocked by high-tide water or low-tide mud in channels just too wide to jump but worth a long, hard look just in case. Again and again you find yourself doubling back and skirting around, often until the only route remaining is one which begins by heading in exactly the opposite direction to where you want to go. Here and there you might find a scaffolding board spanning a gap or a plastic crate acting as a stepping stone, put there by someone 'of set purpose' who either knows there is no other way around or ran out of patience trying to find it.

Having evolved to exploit a niche tidal ecosystem, the halophyte (salt-loving) plant species such as sea kale, sea campion and birdsfoot trefoil that thrive on the saltings have recently found a second niche: on roadsides salted by winter gritting.

FLEET /fliːt/

RELATED TERMS: crike, ooze, saltings

OS: TL 967 114

Fleet

The origins of this word are the same for all four of its meanings: 'a company of ships'; 'swift or nimble'; 'to be ephemeral'; and 'a shallow, narrow creek'. All these uses share a sense of the flow of running water that can be traced back to the common source in the Old Norse word '*fljota*' – 'float' or 'flow'. The meanings had diverged somewhat by the time a later Anglo-Saxon word, '*flēot*' came to mean 'inlet', becoming the ancestor to the modern name for this landform.

Fleet Street in London was named after the Fleet River, whose headwaters fill the bathing ponds on Hampstead Heath but which is thereafter held in captivity to flow in conduits beneath the city streets before making an ignominious entry into the Thames through a pipe under Blackfriars Bridge. The Fleet also gave its name to a debtors' prison and, by association, to the 'Fleet Parsons', members of the clergy who operated within prison and who were, by a legal quirk, protected from prosecution for marrying couples without banns or licence and so ran a booming business in clandestine weddings.

Parley and Towering

This is the clamorous gathering of sea birds at a place where fish are rising, or where fishing vessels are hauling in their catch. Both words come from the south coast, where they were used with nuanced meanings. A 'towering' of birds describes their circling flight above the fish, a sight that, even from miles away, might alert keen-eyed fishermen to a shoal. A 'parley' suggests a vocal congregation, something more like the close-up experience of the birds in and around the water's surface. In this way the two words seem to describe the same phenomenon but from different points of view: one from a distance and one in-among. Coastal fishing fleets have so dwindled over the last century that many more gulls now tower and parley around the bulldozers of landfill sites than around trawlers at sea.

'Towering' is also a word used to describe the rare phenomenon of game birds sky-rocketing when shot in flight. Since the swift descent of a bird is a more usual result of a successful shot, this sudden and swift ascent, which results from neurological damage from the wound, has left many hunters temporarily baffled.

Desire Path

Desire paths wouldn't exist in the perfectly planned city park. These unofficial shortcuts, which become dirt tracks beaten into the grass by footfall, are good indicators of how well the architects of a given space have anticipated the needs, or desires, of its users. Where these needs have been poorly understood or poorly accommodated, these failings are annotated by truncated corners and bare-earth bypasses – direct connections between A and D where the official route passed by B and C.

For some reason Gaston Bachelard, and in particular his 1958 book *The Poetics of Space*, is widely but erroneously cited as the source of this term. Bachelard's work examined architecture as an experienced phenomenon, looking at various types of built environment – nests, wardrobes, corners and huts – from the point of view of the user. Given this focus on how people use spaces he could have been the originator of the phrase, except he wasn't; the term simply doesn't appear in his works. Nevertheless, the continued association of Bachelard with desire paths has itself created a well-worn path, one now so established that people follow it even though it leads nowhere, presumably because it looks good. As Bachelard actually did say in *The Poetics of Space*:

> *What a dynamic, handsome object is a path!*
> *How precise the familiar hill paths remain for our muscular consciousness!*

Moonglade

There is no Americanism more graceful than the word 'moonglade'. It is applied along our New England coast to that path of light which lies beneath the moon upon the sea, and which appears to slope down from the horizon to the place where each observer stands. This broad and luminous track is as distinct from the expanse around it as is any path through the forest from the surrounding trees; and both alike offer a vista for the imagination as well as a delight to the eye.

Studies in Romance,
Thomas Wentworth Higginson, published 1900

What Higginson would have made of later Americanisms it's hard to say, but his appreciation of 'moonglade' was shared by other writers such as Herman Melville and Lucy Maude Montgomery, who exploited its poetic possibilities. This passage, published in Higginson's later years, might give an impression of a whimsical man of letters,

but he was far from that. A fervent abolitionist, he commanded the first regiment of freed black slaves, the First South Carolina Volunteers, during the civil war. He wrote extensively on the need for equality, and campaigned for women's rights and suffrage. It was in response to an article he wrote in the *Atlantic Monthly* calling for female contributors that Emily Dickinson offered her first work for publication. He clearly knew a good thing when he saw it, and he went on to nurture and champion her work.

Higginson's comparison of the reflection to a forest path is misleading because the 'glade' part of this term derives from a now-obscure use of the word 'glad' to mean 'shiny'; it's cognate with 'glint', 'glisten' and 'gleam'. The term 'moonwake' is preferred by mariners, if not by writers, and the solar equivalents of this lovely sight are 'sunwakes' or 'sunglades'.

FENLANDS

I left the waterlogged landscapes of East Anglia for last, thinking that they would be quickly reached and easily defined, but on both counts I was mistaken. I should have known better. My past experiences of driving into Norfolk and Suffolk had all been journeys that became mysteriously elongated, with extra time and distance added like hidden and unexpected charges to a bill. As a result, I don't think I've ever returned home from East Anglia in daylight. While I can accept this is probably just poor logistics on my part and perhaps a reflection on the road network in the east of England, I still have a nagging sense that time and space are somehow altered when you pass into those wide, flat lands.

One morning in early September I headed for the north Norfolk coast. A few downy clouds moved slowly in the big blue sky; the air that blew in through my open window was warm and full of the scents of late summer. It was a glorious day, but I was determined not to let it improve my mood. Thanks to a series of minor and major home crises, I was feeling worn and resentful. At Holme Dunes I wandered in the marram grass,

where the long, tickly leaves brought to mind my dad's technique for banishing childhood grumpiness. His tickles and monotone mantra – 'Don't smile, it might hurt' – were an infuriatingly effective cure when I was five. The recollection brought a smile, though it did almost hurt.

I drove along the coast to Hunstanton, where the foreshore was lined with stooped figures. Thirty or forty people with forks were wandering in the low-tide shallows, turning over the muddy sand like treasure hunters or confused gardeners. At first I thought they were looking for shellfish – cockles perhaps – but when I got closer I could see that none of the diggers were picking out any of the shells they came across. In fact no one seemed to be putting much of anything in the buckets they had beside them. 'How's it looking?' I asked a couple of men who were resting on their forks, chatting. 'Not so good for worms,' one commented, 'still, nice day for it at least.' I mumbled agreement and turned to look again at the industry going on around me with newly comprehending eyes. Worms, of course, for bait; these were anglers looking for bait. Specifically white ragworm, a bait

so prized that it's banned as an unfair advantage in some competitions. The spring tide had provided the opportunity to get to the muds where the ragworms should be found, but the worms didn't seem to be there.

That morning I had been in an angling shop to buy a pair of waders, surrounded by displays of lures and floats and line in the fluorescent colours of a 1980s rave. It seemed to me that much of the paraphernalia of fishing might be designed to appeal to the fishermen as much as the fish. Making use of my new waders, I walked further out onto the mudflats. Crabs scurried in my path through shallow pools. When pursued, they rounded on my booted toes and fended me off, southpaw or orthodox depending on which of their pincers was the biggest. There were grey-pink starfish dotted around, looking as soft and vulnerable as a loop of intestine. I said hello to a man in a baker-boy cap who was feeling in the mud he had just turned. 'What do they look like when you find one?' I asked. 'I've never seen one myself,' he admitted, 'but they say they can be thick as your thumb.' He shrugged, as if to apologise for a small failure. 'I don't mind. It keeps you fit, doesn't it, a bit of digging. I've had five days off work and been fishing for four of them, so that's not bad.' I asked what he'd caught (it seemed the thing to do) and he reeled off a list that would have stocked a decent

fish counter: 'Cod, a few fair-sized ones, couple of trout, little sea bass, bream . . .'

The tide had turned and one by one the bait diggers were giving up the search and walking back up the beach, perhaps reconciling themselves to lesser baits, and to the ones that would get away for want of a ragworm as thick as your thumb.

A couple of days later I drove back to Norfolk to meet the author, naturalist and environmental activist Mark Cocker. I had arranged to meet him in his woodland, Blackwater Carr near Norwich, where I was hoping to pick his brains about the local landscape. We had met once before, but ten years had gone by and I was glad to see a light of recognition in his eyes as I approached, especially because at that moment he happened to be sharpening a scythe. A couple of walkers passed us as we said our hellos. 'I always thought the grim reaper was older!' quipped one.

Mark was anything but grim – far from it. His joy in the woods was clear, even if it was tempered by the unending toil. For much of this toil, he explained, the scythe was an ideal tool, efficient and versatile and much nicer to use than a strimmer. As we walked into the woodland he explained its layout and the work he had been doing to clear ditches and tame the rampant thickets of sallow. Then, sitting on camp stools among towering dewy grasses we talked: about

the woods, the changing landscape, sat-navs and maps, lost broads and decoys. I was reminded again and again of his extraordinary breadth of knowledge, and of his sharp eyes and ears. Often, mid-sentence, he broke off to identify birdsong ('That's a Cetti's warbler') in the distance or a spider in the grass ('I think that's a four-spotted orb weaver'). Mark's observations from the parish he lives in had just become the basis of his tenth book, *Claxton: Field Notes from a Small Planet*, and it was obvious that he was incredibly aware of the web of life in this place. Whereas I had spent the best part of a year being a stranger all over the country – even locations where I had once been at home – Mark had immersed himself in one place. Despite these fundamentally different approaches, we found a shared conviction in the significance of the language we use for nature, and the importance of naming. As Mark said: 'Names are the absolute fundament of relationship and of affection and emotion, because if you don't have name for something you can't build on that relationship.'

I listed the East Anglian terms I was hoping to photograph, almost all of which were connected to water. 'We are dominated by water here,' Mark confirmed, 'which is odd because you don't really see it that much these days. It's been controlled, but this is really a landscape of water . . . Once you start having a relationship with land like I've got here you realise you're just wrestling water all the time.'

This battle with water has been the main sculptor of the East Anglian landscape. Major efforts to drain the fens began in the 1630s when Charles I contracted several syndicates to undertake the engineering work. As with many such projects, the work took longer, cost more and achieved less than was hoped for. The peats that were drained shrank like drying sponges, the ground level dropped below the high-tide mark, and by the end of the century most of the land that had been drained was underwater again. This pattern of drainage, shrinkage and flooding has been repeated over the centuries, leaving vast areas of land below sea-level and requiring ever-more extensive feats of engineering to keep the waters at bay. This cycle may soon be broken: the Great Fen Project, which began in 2008, aims to return some of the drained agricultural land to fen by allowing it to flood. Perhaps fenland farmers might follow the example of their predecessors – known as 'slodgers' in the seventeenth century – who wore stilts to tend their flocks and fish the creeks.

I left Mark to his scything and went to take pictures of pingos and crikes. As I drove home later – in the dark, of course – I realised the black mood that had afflicted me two days before seemed to have dissolved into the light and the space and the hidden waters of the flatlands.

Crike

'Crike' is an old form of the word 'creek'. Both words are derived from the Old Norse '*kriki*' via the Middle English '*krike*', and are broadly applied to inlets on the coast, on rivers and on lakes. From the sixteenth century onwards, 'creek' became the common term except for pockets of use in East Anglia where the old spelling persisted. Today the word is found in very few places – in Lincolnshire mostly – but even there the spelling is often modernised at the earliest opportunity.

'Creek', 'crike' and their antecedents have all been figuratively applied to the crannies of the human body. Sharing the Old Norse origin, the Icelandic for 'armpit' is '*handarkriki*' and the Old Danish word for 'groin' was '*laarkrig*' (literally 'thigh-nook'). In his *Anatomy of Melancholy*, published in 1621, Robert Burton used 'creeke' to denote the ventricles of the heart, and there is an even earlier use of the word in the form 'crice', meaning the cleft between the buttocks.

CARR /kɑ:(r)/

RELATED TERMS: mire, moss, bog

OS: TG 306 076

Carr

In Lincolnshire, this word is used to refer to either a wet bog or boggy ground that has been drained and made into a meadow. Elsewhere, and more generally, a 'carr' is a transitional landscape caught between fen and woodland. As a fen becomes more overgrown with riparian shrubs and trees, the ground surface slowly rises with an accumulation of leaf litter and thus becomes drier. Over time, a carr might eventually resemble a dry woodland but often they remain waterlogged.

Alders, particularly associated with carrs, are a 'pioneer' species, able to thrive in poor soils thanks to their symbiotic relationship with bacteria in their root nodules that absorb nitrogen from the air and make it available to the tree. In return, the tree provides sugars to the bacteria. Alders raise the fertility of the soil, making their role in the transition of fens to carrs particularly important. Timber from alders is highly resistant to rot in water and, in fact, remains durable only as long as it's kept damp, making it a valuable material for boatbuilding, troughs and underwater structures. The pilings that support the Rialto in Venice were made from alder wood and have lasted 420 years.

Marfer

Alongside the bottom of a hedge there is almost always a strip of grass that lies just out of easy reach of the trimmer and the plough, and so escapes both. In Lincolnshire, this grassy border to fields and lanes is called 'marfer'.

Field margins as narrow as a metre support thriving communities of wild flowers and invertebrates. When left uncultivated by farmers, these borders also provide shelter for ground-nesting birds such as lapwings and skylarks, both of which were once a common sight on farmland but are now critically endangered through loss of habitat.

Roadside marfer is more likely to harbour crisp packets and cans, but it also has an agricultural connection. Drovers used to call these grassy verges 'the long acre' in reference to their function as on-the-hoof pasture, the original drive-through perhaps. Turning onto a single-track road that is not only edged with marfer but has a strip of grass down the middle is, for me, a clear sign that I am probably heading somewhere interesting. These miniature central reservations surely deserve their own name but I haven't been able to find one. I've come up with 'mid-marfer', 'sump-scrubber' (a reference to the way the grass brushes against the underside of your car) and 'rohican' (a portmanteau of 'road' and 'mohican').

I should note that marfer also appears in *The Place-names of Shropshire* by Margaret Gelling and H.D.G. Foxall, where it's defined as 'a boundary furrow'. This may well be the original meaning, but I think the Lincolnshire divergence has better prospects.

Stagnal

'Stagnal' means 'living, growing or delighting in a pond, marsh or fen'. This definition comes from a tome entitled *An Expository Lexicon of the Terms, Ancient and Modern, in Medical and General Science*, written in 1860 by Robert Gray Mayne. I think it says something about our dismissive attitude to wetlands that the term has barely featured in dictionaries since the late nineteenth century, whereas equivalents such as 'aerial' and 'arboreal' are in common use. Even 'bathysmal' ('of, like or pertaining to the depths of the ocean') makes it into the standard Oxford dictionary, yet which of us will ever visit the bathysphere? We do use the related word 'stagnant', of course, but there's little delight in this word, only mild disgust at best. If we gave marshes, fens and bogs their proper value and consideration we would have reason to use 'stagnal' more, and to overcome our prejudice against wetlands in general.

Wetlands deserve our care and attention for a number of reasons: they protect against flooding by acting as reservoirs to absorb tidal surges and extreme rainfall, they are highly effective and efficient at sequestering and storing carbon, and they are among the most diverse and productive ecosystems on the planet.

We should be delighting in these places. In fact, we should become more stagnal.

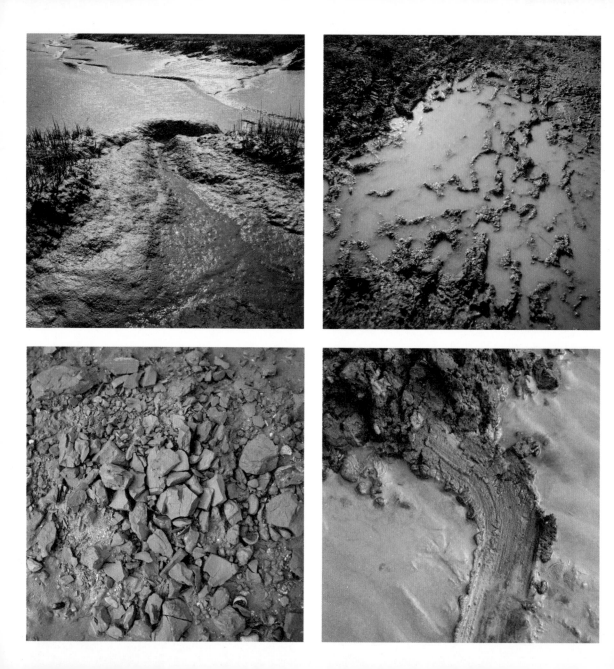

Mud

The British know mud like the Inuit know snow.* It's been such an ever-present part of life here that its vulgarity sets the bar for everything and everybody – common as muck. Common it may be, but it's not without variety. Like snow, mud has myriad forms, and the English language is at its most malleable and expressive in naming and describing them. These days, our attitude to mud is rather dismissive. Beyond the childhood delight in muddy puddles and mud pies, which have been promoted most diligently by Peppa Pig and laundry-liquid manufacturers, we see mud as an inconvenience to be avoided or a trial to be endured in extreme assault courses. It's worth remembering, however, that mud has been an important building material for millennia, first as wattle-and-daub and later baked into bricks.

* There is a lively debate among linguists about how many words the Inuit have for snow. Franz Boas, an anthropologist who worked in northern Canada in the 1880s, sowed the seeds of the argument when in his book *Handbook of American Indian Languages* he noted distinct 'Eskimo' words for 'snow on the ground', 'falling snow', 'drifting snow' and 'snowdrift'. Boas went on to comment that 'where it is necessary to distinguish a certain phenomenon in many aspects, which in the life of the people play each an entirely independent role, many independent words may develop, while in other cases modifications of a single term may suffice'. From this simple observation grew an increasingly hyperbolic meme that by the 1980s had penetrated both linguistic orthodoxy and the popular imagination. Linguistics professor Geoffrey Pullum was not convinced. His essay 'The Great Eskimo Vocabulary Hoax' (1989), poured scorn on the 500-words-for-snow trope and argued that the eight relevant languages (Siberian and Alaskan Yup'ik and the Inuit languages of Canada and Greenland) don't have lots of words for snow at all. Pullum pointed out that most of these words are compound terms that could be translated into phrases in any language and would be just as capable of describing snow with the same precision. Others have contended that just because you could construct the phrase 'snow that's good to run a sledge on' in any given language, there is something significant about having a single word that can do the job with a fraction of the linguistic effort, as does '*piegnartoq*', a word from the Inuit community in Cumberland Sound, Labrador.

In the hands of a potter or sculptor, mud can take on forms infinitely more complex than a simple brick, but from the crudest earthenware pot to the finest porcelain statuette all ceramics begin as muddy clay pulled from the ground. In the biblical creation story, the first man is formed of the earth too, moulded by the hand of God into something like a figurine and a vessel. For all its humble beginnings, then, mud has great potential; where there's muck there's brass. And so let us celebrate the mud, clag, cart and wallow, the plash, stodge, slub and slather.

The fenland dialects, springing as they do from an amphibious landscape, offer more than their fair share of muddy words. Among these are words for gradations on the scale of consistency from water to earth starting with the washy and watery 'slur' and 'sluther', to the soft, wet 'sludge' and 'slub' and then the thick and adhesive 'squad'. Perhaps we could introduce these definitions as standard measures of sloppiness and replace the often unhelpful descriptions in recipes.

Here are a few more of my favourite muddy words from the fens and elsewhere:

Stabble /ˈstab(ə)l/ (English dialect): Mud churned up by the footfall of people, animals or both. In wet years, Glastonbury Festival becomes the largest stabble in the world. 'Stabble' also refers to the muddy footprints that continue beyond the source of mud and into the nightmares of people who buy white carpets.

Clart /klɑːt/ (Scottish and Northern English dialect): This is the kind of mud that sticks to your boots and then sticks to itself. As the weight of material accumulates, a trudge over a field becomes increasingly strenuous to the point where you feel that you've been fitted with a ball and chain.

Blash /blaʃ/ (English dialect): Somewhere on the line between muddy water and watery mud, a word that can be used disparagingly to describe wishy-washy tea, soup, beer, talk or anything else lacking in the necessary substance.

Cutcha /ˈkʌtʃa/ (Anglo-Indian colloquialism): Dried mud, flaky and friable, and used figuratively to describe something similarly insubstantial and makeshift. The opposite of 'pukka' (meaning 'solid, well-made and proper' and also derived from Hindi).

Loblolly /ˈlɒblɒli/ (Chiefly US colloquialism): A mud hole, especially one with a deceptive dried crust on the surface. Also a name for a thick stew of similar consistency. By the sound of this word,

I'd be inclined to use it to describe the inelegant flailing of anyone who finds themselves stuck in a mud-suck: 'I loblollied about for half an hour before I got free, and lost a boot in the process.'

Richard Askwith devotes a chapter of his excellent book *Running Free* to 'The Brown Stuff', and suggests a few new words to add to the list, including: 'retch, for the dark unwholesome brew that tends to gather where rural footpaths pass under major roads. And snelt for the peculiarly sticky, cold kind of mud that is left when a heavy snowfall has just melted.' Askwith may be joking when he says he's thought of compiling a dictionary of mud, but I sincerely hope he isn't. I'd buy it.

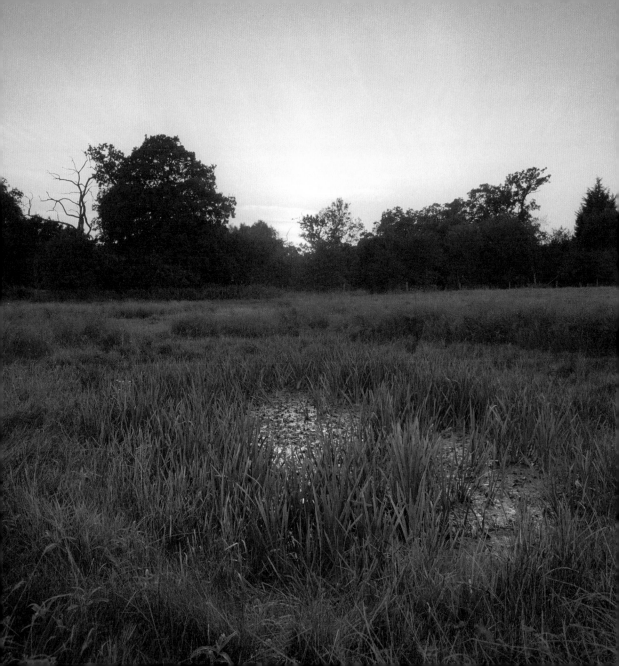

PINGO /pɪŋɡəʊ/

RELATED TERM: swag

OS: TL 926 954

Pingo

In landscapes where there is permafrost – a layer beneath the surface of the soil that remains frozen year-round – small hillocks called 'pingos' can occur. Pingos are formed by localised accumulations of ice, which raise the surface soil like a blister raising the skin. These formations can continue to grow for many years, eventually breaking and opening like volcanoes at their peaks.

Where climate change has led to the melting of the permafrost, it's possible to see the traces of former pingos as shallow depressions in the ground. Geographers have unofficially adopted the term 'ognip' to refer to a collapsed pingo that has become a pond, lake or dip.

The word 'pingo' comes from an Inuit word meaning 'small hill', the word 'ognip' is 'pingo' reversed. The scientific term for these features is 'hydrolaccolith' – not so bad forwards, but try saying it backwards

MEOL /miiL/

RELATED TERMS: machair, dune

OS: TF 709 449

Meol

The name for these large, vegetated, coastal sand dunes shifts as often as the sands themselves. They are known as 'meols' in Lincolnshire and 'meals' in Norfolk, and variants include 'melle', 'male', 'meale', 'miel', 'mell' and 'meele'. They turn up in place names such as Ingoldmells in Lincolnshire and Rathmell in Yorkshire. All these words share a common Scandinavian ancestor dating back to the ninth Viking expansion into England. The spread of their use corresponds to the historic area of Norse influence, the Danelaw, which stretches from the Thames to the Tees.

Meols are dunes that have been colonised and stabilised by vegetation. The most important species in this process is marram grass, whose roots grow at a prodigious rate of nearly one centimetre a day. The ability to establish a binding root network quickly is crucial in stabilising the dune structure, and once marram has established itself, other species can colonise.

The long, slender blades of marram grass have evolved to lose very little moisture and to be able to survive the continual, gradual inundation of loose sand. Their shape also makes them act as windblown scribes, restlessly drawing lines in the sand like settlers on a claim.

Scalp

Found in shallow waters, these are shellfish beds, usually of mussels or oysters. There are several scalps on the north Norfolk coast. The gently shelving beaches of mud and sand are littered at the low-tide mark with the empty shells of mussels, razor clams and cockles that crunch like broken china when you walk over them. There are also scalps in Scotland, where the word is usually spelled 'scaup'. This Scottish spelling is also a species of duck (Latin name *Aythya marila*) that almost certainly took its name from its preferred feeding ground, its diet being largely mussels and other shellfish.

There are still productive mussel scalps in the UK, but almost all of the oyster scalps in British waters were fished out by the early 1900s. A hundred years before, the oyster had been a food of the masses. According to Natural England, the population of London consumed more than 700 million oysters in the year 1864. At the time, a servant's terms of service would sometimes stipulate how many meals a week they would be expected to eat oysters. The subsequent transition from food for the poor to luxurious delicacy is a model of supply and demand. It had apparently been known since Roman times that harvesting more than a fifth of the oysters on a scalp was unsustainable, yet ever greater numbers were dredged as suppliers tried to make money in a flooded market. Once the scalps were spent, the supply dried up and the demand pushed prices way beyond the realm of cheap servant's fodder.

Many of the scalps now found on old maps are little more than memorials to a once-thriving industry destroyed by greed and short-term thinking.

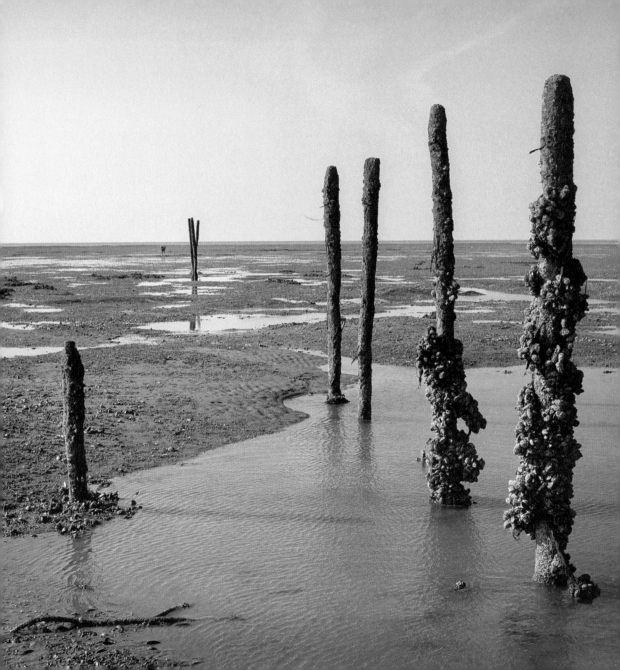

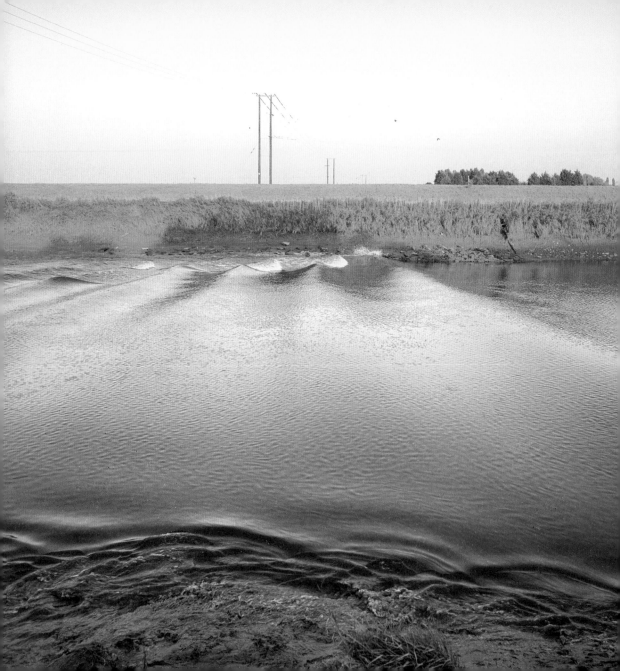

EAGRE /ˈeɪɡə(r)/

RELATED TERM: bore

OS: TF 600 114

Eagre

This is the name given to tidal bores on fen rivers. One eagre occasionally runs eight miles inland, up the River Great Ouse to Wiggenhall, where it's known as the 'Wiggenhall wave'. I wanted to try to photograph this bore, but with only scant information about the conditions necessary for its appearance I arrived only half expecting success. I'd pinned my hopes on a
spring tide and a very rough estimate of the speed of the wave, but after an hour waiting on the riverbank I was quickly losing confidence in my assumptions. As I began to consider giving up, I noticed three men sitting on the bridge behind me. They seemed to be looking downstream and even at a distance I thought I detected an air of expectation in their manner. My resolve settled a little, and as the minutes wore on more people kept appearing on the bridge, each new group increasing my certainty that the wave would soon arrive.

Then I had an awful thought: What if the only reason this small crowd had gathered was that they had seen me, with a camera, set up in preparation for what was sure to be a momentous event, and had decided to wait and see what was going to happen? What if nothing did?

And then, at the distant bend in the river, there was a sudden little shrug on the water's surface and a crease appeared. Moving slowly but steadily, the crease rolled upstream, and soon I could hear the wave rushing over the banks as the bore pushed its way against the flow. The eagre sloshed under the bridge and the crowd ran to the other side to watch it go on its way. Glad to have been a sideshow and not the main attraction, I packed up and did the same.

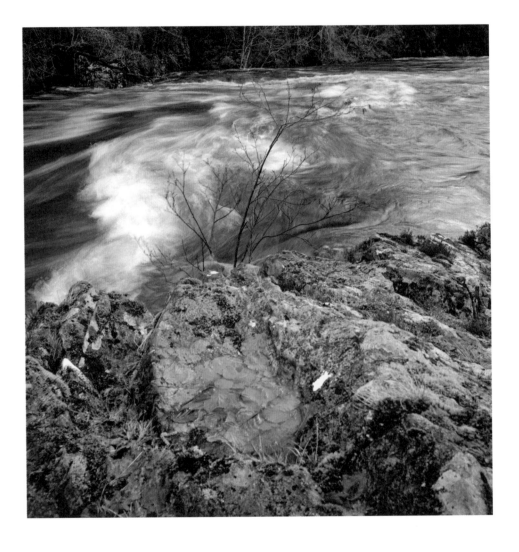

Afterword

I've never been much of an angler.

I did once catch a young grayling on a fly, but the joy of this success curdled into dread when I found I couldn't unhook and release it as I'd intended. It became clear that I would have to end its suffering. Having killed the little fish as humanely as I could manage, I felt I couldn't then throw it away, but burial seemed a little melodramatic, so I cooked and ate it. It was more like a funeral than a meal. If it had been a bigger fish, one always intended for the pan, I would have felt triumphant – and also not so hungry – but as it was, the whole episode seemed sad and shameful. I've not touched a fishing rod since.

In many ways, catching that fish was what spoiled my experience of fishing. Before that happened I was content to sit in hopeful meditation, occasionally swishing the rod about and letting the river lull me.

When I unexpectedly hooked the commission to do this book I had a moment of panic, not unlike the one I felt when I lifted the grayling from the water. This was the chance I'd always wanted, to make a book of my own about something that I really loved, and yet I couldn't tell which was the stronger emotion, delight or horror.

As I write this, the book is nearing completion and I'm beginning to give serious thought to the prospect of it actually existing as an object in other people's lives as well as my own. I have often wondered, during the travelling and photographing and writing and researching and more travelling, whether I would have been happier, calmer or healthier had I never landed this opportunity. I certainly didn't anticipate how difficult I would find the work, but then nor did I realise how rewarding it would be. In particular, the discovery that so many people seem to respond to the idea has been overwhelming and humbling.

I don't feel as much like the creator of this work, as its curator. It came to me through chance and circumstance, but I've done my best to look after it. I'm glad that it's in a fit state to now be released back into the flow of ideas, to make its own way, wherever it goes.

Perhaps that makes up for the grayling.

Acknowledgements

I've had a lot of help, I needed it and I'm grateful for all of it. In the very early days of the idea that later became this book Kate Rew and Lisa Darnell gave crucial encouragement without which I would probably not have taken it further. When I finally did take it on Sara Montgomery at Guardian Books let me run with it, an expression of confidence for which I will always be very thankful.

Laura Hassan at Guardian Faber skillfully guided me through how to make a book, always improving my efforts with her notes and never wavering in her enthusiasm. Others whose work has been crucial in making this book what it is include Eleanor Crow, Rich Carr, Sophie Lazar and Gemma Wain.

The skills and knowledge of Liam Irving, Graham Douglas and Ian Craigie of Mountain and Water Safety got me to places that I wouldn't have otherwise reached. Without Jack's Garage fixing the van I would have been going nowhere at all.

I claim sole ownership of any and all errors but there have been many people who have generously offered wisdom and advice in the course of this work. Robert Macfarlane has, from the earliest stages of this project, been incredibly supportive and kind.

I have benefitted from his guidance, found great inspiration in his work and through him discovered many precious resources that I might otherwise have overlooked. Iain Finlay Macleod advised on Lewis' peat, Guto Roberts at Cwm Idwal helped me understand Wales and the Welsh language better and John Atkinson gave me insight into the Lake District. When I was in danger of sinking under the weight of it all Mark Cocker got me back afloat with his buoyant and brilliant ranting and guided me into the fenlands.

For lodgings, food and other nourishment my thanks go to Drystan and Dawn, Richard and Dorcas, Ralph and Carla, and especially to my wonderful mum and dad. Particular thanks to Matt Politano for his excellent company, good humour and keen eye and to Chris Hadley for saying I could write and making me believe it.

I'd also like to thank Jonathan Hourigan, Kathrin Böhm, D.J. Simpson, Andrew Wadge, Ben Oliver, John Galliver, Meriel Martin, Pred, The Arts Council, Hammer Labs and Labyrinth.

Finally I want to thank my wife Sarah for putting up with me at my worst, motivating me to do my best and supporting me regardless.

Bibliography

AA Book of the British Countryside (Drive Publications, 1980)

The Oxford English Dictionary (Oxford University Press, online edition)

Campbell, Anne *et al*, *Rathad an Isein – The Bird's Road, a Lewis moorland glossary.* (FARAM, 2013)

Clarke, Audrey N., *The Penguin Dictionary of Geography 3rd ed.* (Penguin Books, 2003)

Dwelly, Edward, *The Illustrated Gaelic–English Dictionary* (Dwelly-d online version)

Evans, George Ewart, *Ask the Fellows Who Cut the Hay* (Full Circle Editions, 2009)

Fortey, Richard, *The Hidden Landscape* (The Bodley Head, 2010)

Grigson, Geoffrey, *The Shell Country Alphabet* (Penguin Books, 2010)

Healy, Hilary, *A Fenland Landscape Glossary for Lincolnshire* (Lincolnshire Books, 1997)

Knox, Alexander, *Glossary of Geographical and Topographical Terms* (Edward Stanford, 1904)

Lopez, Barry, ed., *Home Ground, Language for an American Landscape* (Trinity University Press, 2006)

Macfarlane, Robert, 'A Counter-Desecration Phrasebook', in Gareth Evans and Di Robson, ed., *Towards Re-enchantment: Place and its Meanings* (Artevents, 2010)

Monbiot, George *Feral* (Allen Lane, 2013)

Muir, Richard, *Landscape Encyclopedia* (Windgather Press, 2004)

Onions, C.T., ed., *The Oxford Dictionary of English Etymology* (Oxford University Press, 1966)

Poucher, W.A., *The Magic of Skye* (Constable and Co., 1982)

—, *The Scottish Peaks* (Constable and Co., 1989)

Rackham, Oliver, *The Illustrated History of the Countryside* (Seven Dials, 2000)

Toghill, Peter, *The Geology of Britain* (Airlife Publishing, 2009)

Whittow, John B., *The Penguin Dictionary of Physical Geography 2nd ed.* (Penguin Books, 2000)

Wilson, Philip, *A-Z of Tree Terms* (Ethelburga House, 2013)

Wright, Joseph, *The English Dialect Dictionary* (Oxford University Press, 1898–1905)

Index

(entries in bold type refer to main articles)

rain on 19

Darwin, Charles 85, 164

dean, as related to *scowle* 158

Deben estuary 183

Defoe, Daniel 191

dell 186

dene, as related to *scowle* 158

desire path 204

 as related to *holloway* 173

'devils are getting married', as
 related to *monkey's birthday* 181

dicky 177

Dictionary of Newfoundland English
 169

Dictionary of the Welsh Language, A
 (Pughe) 152

dingle, as related to *dell* 186

Disappointment Pot 115

doake 121

'Dream of White Horses, A' 11

druim, as related to *arête* 38

dry-stone walls 131

dub 118

dumbledore 164

Dumbledore, Prof. Albus (*Potter*
 character) 164

dune, as related to *meol* 226

eagre 231

Eden Valley 102

Eel Pie Island 194

Ellylldan, as related to *will-o'-the-
 wisp* 166n

epilimnion 122

Erlandson, Axel 163

erratic 117

 as related to *unconformity* 82

escarpment 104

 see also scarp

Euridice 95

'Evening Walk, An' (Wordsworth) 99

Exmoor 17

*Expository Lexicon of the Terms . . .,
 An* (Mayne) 218

eyot, as related to *ait* 194

feadan 67

feith 67

fell 102

Fell Beck 95

Feral (Monbiot) 185

Feynman, Richard 127

ffridd 131

ffrwd 146

Fiacaill a'Choire Chais 30

firn, as related to *névé* 48

flatfish 121

fleet 201

 as related to *ooze* 197

 as related to *saltings* 198

flotsam, as related to *tidewrack* 93

flounder tramping 121

foggy bumbler, as related to
 dumbledore 164

Footdee 89

Forest of Dean 158

Fortey, Richard 8

Foster, Edward 186

Foxall, HDG 217

fox's wedding, as related to
 monkey's birthday 181

fraon 40

gall burr, as related to *witches broom*
 79

Gaping Gill 95–6, 115

Gardyloo Gully 35

Gelling, Margaret 217

*General Dictionary of Provincialisms,
 A* (Holloway) 166

Genesis, Book of 82

geo, as related on *zawn* 11

geode, as related to *thundereggs* 143

geology 82–5

ghost nets 93

ghost rain, as related to *monkey's
 birthday* 181

gill 99

 see also beck

Gilpin, William 184

Ginny Greenteeth 112

Glastonbury Tor 12

glen 75

DOMINICK TYLER grew up in rural Cornwall. After studying philosophy at UCL he became a documentary photographer. He has worked for the *Guardian*, the *Independent*, *Le Monde* and Médecins Sans Frontières among many others. In his personal work Tyler frequently explores the relationships between people and their environment – his ten-year project 'The Edge of Two Worlds' documented the changing lives of a community of Innu in northern Canada. He was the photographer on the book *Wild Swim*, written by Kate Rew. The Landreader Project carries on where where *Uncommon Ground* leaves off. Based online at www.thelandreader.com, it aims to collate a complete database of landscape language from the UK, in part from words and terms submitted by members of the public.